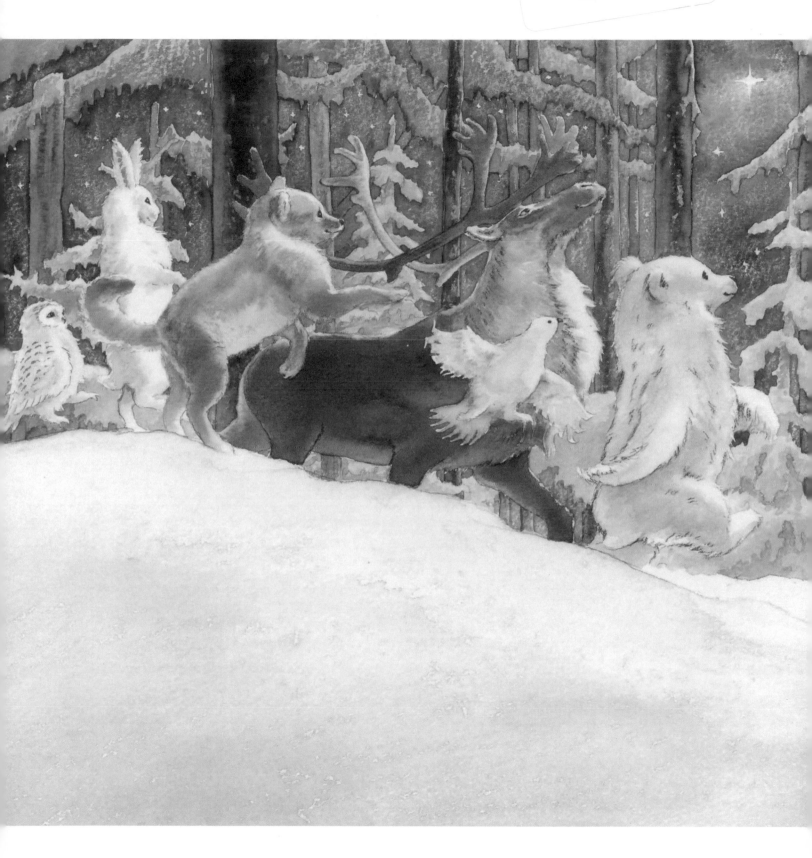

I'd like to invite you on a journey to explore and discover your hidden potential

AN INVITATION

CAN YOU REALLY BELIEVE THAT YOU CAN DRAW? COULD YOU TRUST THAT YOU CANNOT JUST DRAW BUT THAT YOU HAVE THE ABILITY OF MICHELANGELO AT YOUR FINGERTIPS? DO YOU KNOW THAT THROUGH DRAWING YOU CAN FIND OUT WHO YOU REALLY ARE AND HOW YOU SEE, OR DON'T SEE, THE WORLD AROUND YOU? DO YOU REALIZE THAT DRAWING CAN TAKE YOU BEYOND THE LIMITATIONS OF YOUR THOUGHTS, OPENING A NEW AND VAST UNIVERSE OF BEAUTY THAT IS FAR BEYOND OUR ORDINARY EVERYDAY PERCEPTION?

OK, let's backtrack a little before we get too carried away. I believe that you have inside you all of the above and more. That doesn't mean to say that you are going to see and draw as well as Michelangelo overnight, or even by the end of this book. What it does mean is that I'm certain you have that potential hidden away, so I'd like to invite you on a journey to explore and discover that potential through these pages. If, by the end you disagree, well, that's fine, but at least allow yourself to begin with the possibility in mind that it may be true.

This really is just a beginning, a scratch on the surface of what you're capable of.

THE Magic OF DRAWING

THE Magic OF DRAWING

Bring your vision to life on the page

CLIFF WRIGHT

IMPACT

A DAVID & CHARLES BOOK
Copyright © David & Charles Limited 2008

David & Charles is an F+W Publications Inc. company
4700 East Galbraith Road
Cincinnati, OH 45236

First published in the UK in 2008
First published in the US in 2008

Text and illustrations copyright © Cliff Wright 2008

A catalogue record for this book is available from the British Library.

ISBN-13: 978-1-60061-093-6 paperback
ISBN-10: 1-60061-093-5 paperback

Printed in China by Shenzhen Donnelley Printing Co Ltd for David & Charles
Brunel House, Newton Abbot, Devon

Senior Commissioning Editor: Freya Dangerfield
Editorial Manager: Emily Pitcher
Project Editor: Katie Hardwicke
Art Editors: Martin Smith and Sarah Underhill
Production Controller: Kelly Smith
Photographer: Kim Sayer

Visit our website at www.davidandcharles.co.uk

David & Charles books are available from all good bookshops; alternatively you can contact
our Orderline on 0870 9908222 or write to us at FREEPOST EX2 110, D&C Direct, Newton
Abbot, TQ12 4ZZ (no stamp required UK only); US customers call 800-289-0963 and Canadian
customers call 800-840-5220.

CONTENTS

6 INTRODUCTION:
 AUTHOR'S NOTE

8 AN INVITATION

12 PART ONE:
 HOW WE SEE

52 PART TWO:
 TOWARDS A FINE TOUCH

86 PART THREE:
 FROM IMAGINATION TO PAGE

126 ACKNOWLEDGMENTS

127 INDEX

To stop moving around, to sit quietly on the grass,
to switch off the world and come back to the earth, to
allow the eye to see a willow, a bush, a cloud, a leaf, is an
"unforgettable experience". FREDERICK FRANCK — THE ZEN OF SEEING (1887—1966)

AUTHOR'S NOTE

We live in a results-obsessed world. Our schools, colleges and places of work are dominated by the need to meet targets. Our children are tested and assessed at earlier and earlier ages and the general focus of education is on striving towards pre-determined goals. It's a scary place to be, because what if those targets aren't met? What if one of those children needs a little more encouragement and time than the next? This is not the place to find the magic of drawing. If you want to be able to draw what you see; to lose your fears of not being good enough; to respond intuitively; to discover how it is that a single line, coming from pure observation, can describe shape and character perfectly, then you must direct your attention away from the result and on to the journey. Ultimately it is the easier way – after all, the result hasn't happened yet; the journey is happening, right now!

So here is the point of this book. It will set you on a path of tried-and-tested ideas which, if followed attentively, will bring you glimpses of the real creative soul that exists within us all. It will ask you to experience fully the process of creativity and thereby provide an alternative approach to that which is entirely based on outcome. Of course you want to learn to draw better and you will feel disappointed if you don't fulfil that desire. But after many years of teaching hundreds of people, I can guarantee that if we focus on making the process right, the results will come along all by themselves. Let's enjoy the experiment!

Of course you want to learn to draw better... and I can guarantee that if we focus on making the process right, the results will come along all by themselves

Images from a series of Christmas cards commissioned by Paperlink for Greenpeace, 1996.

WHERE DOES THIS BOOK COME FROM?

Over the 20 or so years that I've been working professionally on children's books, I've been asked to visit numerous schools to share my experience. Having accepted these invitations (very reluctantly at first, through extreme fear on my part!), I found that they nearly always turned into drawing demonstrations. After a while it seemed obvious to get the children drawing, too. One thing led to another and I was asked to run workshops for both adults and children at exhibitions like Art in Action, in Oxfordshire.

Having conquered the above mentioned fears, I discovered a passion for trying to find the universal in drawing. Are there practices that will work for all? What are our barriers to success and how best can we transcend them? Countless workshops and hundreds of willing victims later, I still have an increasing fascination with those basic questions. We are all different in how quickly or not we might respond to the exercises and ideas presented here but experience tells me that they work with everyone. Hopefully, they are flexible too. Often the best ideas for new explorations in drawing come from the students themselves. So, after you've tried these exercises, please feel free to adapt and play with them to suit your needs.

Drawing can take you beyond the limitations of your thoughts to open a new and vast universe of beauty

WHAT DOES IT REQUIRE OF YOU?

Whether you have drawn before or not, the first requirement has to be a willingness to face your fears and just get on with it. By far the most frequent comments that I hear on workshops are either, 'I'm no good at drawing' or, 'I was told I'm no good at drawing'. Are you willing to give yourself a chance for success? Drawing is a great medium for experimentation because nothing is set in stone – you can always do another drawing if you don't like the first one. So a certain amount of courageous determination is needed. It will help a great deal to focus your attention on the journey, rather than the result – some discipline therefore helps.

Other things that will give you an advantage are a pair of eyes and a passion to want to use them fully. You can either look at something or you can really see it – the difference is vast. So there needs to be some desire to look beyond the obvious; to go deeper than the surface appearance. This exploration can go as far as you want and could be a lifetime's work. Beware though, as you begin to see more accurately you may develop a growing awareness that for the most part we only see a fraction of what we're capable of perceiving. Thus, drawing can be your own personal vehicle to reach beyond that surface layer, to explore the unlimited beauty and nature of the world and present it in a new way for those that have not yet seen it for themselves.

The theme of this book, as presented in the context of my own vision, may be labelled a type of fantasy illustration. The exercises are what I use, or have used, to create the images that you see included. The message of the practices however can be applied to all forms of drawing. So, although this book has my name on it and is full of my artwork, in reality it's about you. Yours is a unique voice with original things to say – I am hopeful that what follows will allow you to find or deepen your expression of that voice. So it requires you to want to draw like yourself – not like me or anyone else. There is a temptation to judge your drawings against those of others. I think it's of far more value to compare your efforts only with yourself and enjoy the progression.

Using the experiments that are to follow, and illustrated by the examples from the willing victims of some of my workshops, I have seen a lot of people change their ideas about how well they can draw. Often someone will 'hit the mark', or create a truly wonderful image, or a perfect line within one drawing. The result doesn't have to be realistic – it could be totally abstract – but it will have captured a mysterious essence. This mystery is hard to define in words but it is something that everybody recognizes instantly. For me, that is the true magic of drawing and I believe that it resides within us all.

IMPORTANT NOTE!

YOU WILL GET THE MOST FROM THIS BOOK BY WORKING THROUGH IT IN SEQUENCE — EACH EXERCISE BUILDS ON THE LAST, ESPECIALLY IN THE FIRST PART. PLEASE READ THROUGH THE EXERCISES AND FOLLOW THE INSTRUCTIONS VERY CAREFULLY *BEFORE* YOU ATTEMPT THEM.

Somewhere...

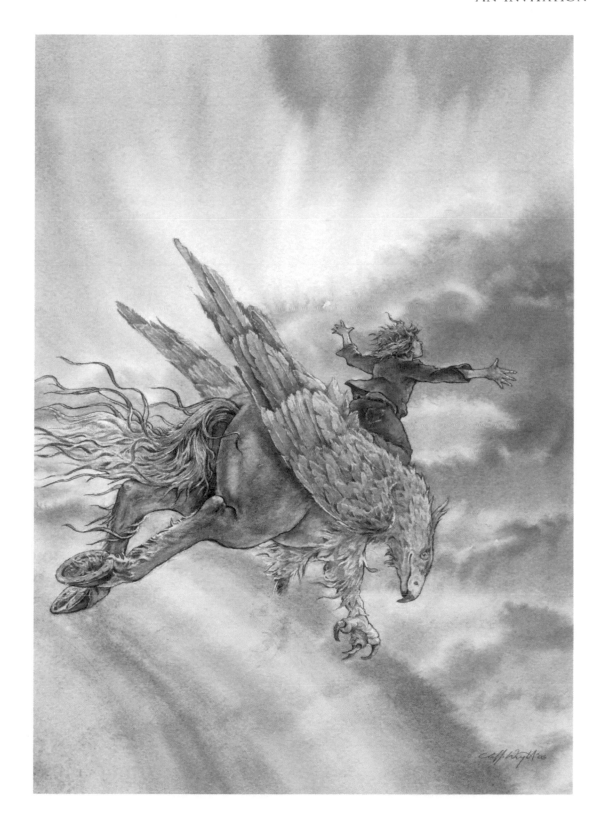

Part one — How we see

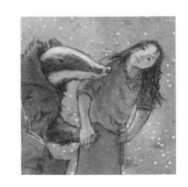

'So, what are our eyes for? To see the incredible landscapes, skies, mountains, shapes, colours, fields of red poppies, that momentarily make us stop? Creating that moment that is no moment anymore, but a vision of no time; transforming. Where the heart opens: giving and receiving beauty and joy where our whole being is part of all – from the infinite space to the infinite small.' HANS ARP (1887–1966)

HAVE YOU NOTICED HOW CHILDREN (ESPECIALLY THE VERY YOUNG) ARE GREAT AT SEEING THINGS? THEY FIND ALL KINDS OF DETAILS IN A PICTURE OR A LANDSCAPE THAT CAN COMPLETELY ESCAPE THE NOTICE OF MOST ADULTS. TO HELP YOU FOCUS ON WHAT WE SEE AND DON'T SEE, THIS SECTION WILL EXPLORE YOUR CONTROL OVER YOUR SENSES, ESPECIALLY VISION, AND HELP YOU TO BUILD UP A LIBRARY OF PRACTICES THAT WILL EASE THE PROCESS OF DRAWING FROM YOUR IMAGINATION.

Why start here? I discovered that if I'm sketching something new sometimes the drawing starts to go wrong – I've begun to draw what I think is there, or even what I want to be there. I've become lazy with my vision. If I re-focus my attention and really look again, the ability to draw returns and the image forms. The problem was not with the drawing but with the seeing. I have developed the following exercises to help overcome this.

The feather exercise (see pages 26–31), is the groundwork and, in fact, is fundamental to the whole book. See it as your bread and butter – it will be referred to throughout and built upon as you progress. You could do this exercise with any object, but I recommend that you use a feather (ideally the same one) for all of the appropriate exercises suggested in this first section, at least

for the first time that you try them. It will give you the chance to experience a depth of seeing not normally available and allow you to see your progression more easily. Once you are used to the techniques then feel free to experiment with other subjects, simple or complex, that interest you too.

'Ah,' he said, 'I see that you begin to understand.'

LEARNING TO SEE

The aim of art is to represent not the outward appearance of things, but their inward significance.' ARISTOTLE (384—322 BCE)

TO BEGIN, HERE IS AN EXPERIMENT WHICH DEMONSTRATES HOW WE SEE THINGS AND SHOULD, AT THE SAME TIME, HELP DEVELOP YOUR CONFIDENCE. OUR ABILITY TO RENDER WHAT IS IN FRONT OF US IS DIMINISHED BY DRAWING WHAT WE THINK WE SEE, RATHER THAN WHAT IS ACTUALLY THERE. WHAT IS NEEDED IS A FRESH OR UNCONVENTIONAL WAY OF SEEING AND THE FOLLOWING EXERCISE WILL ENCOURAGE YOU TO DO JUST THAT. DRAWING THE HUMAN FIGURE CAN BE DAUNTING BUT IT DOESN'T HAVE TO BE. FOR NOW, FOLLOW THE WORDING CAREFULLY, COPY WHAT IS THERE AND TRY NOT TO BE TOO CONCERNED WITH HOW IT TURNS OUT.

SEEING

Although the figure drawing opposite is original and very specifically posed to test how you see, this exercise is not new (you may have seen versions of it elsewhere). The reason that I've included it and put so much emphasis on it, is that I've found nothing else that better demonstrates how we see beyond appearance to discover the essence of form.

Don't try to produce an accurate and detailed figure drawing – look beyond the need to find correct proportions; this is not a proportions exercise. Keep focused on the overall shapes and let your eyes see and your pencil follow.

You will need

A QUIET PLACE FREE FROM DISTRACTIONS
AN ALARM CLOCK
A SHARP 1B PENCIL
TWO SHEETS OF A4 PAPER

SEEING EXERCISE — DRAWING 1

5 minutes

Read through the instructions below carefully before attempting the drawing.

1 Look at the drawing opposite until you are familiar with the pose. Set the alarm for 5 minutes.

2 Begin a drawing copying the figure and filling your sheet of paper in the same way that the drawing fills the white space. Make sure you fill your whole sheet of paper.

3 Finish your drawing on the dot of 5 minutes and don't worry if you haven't completed the whole figure – everyone draws at different speeds.

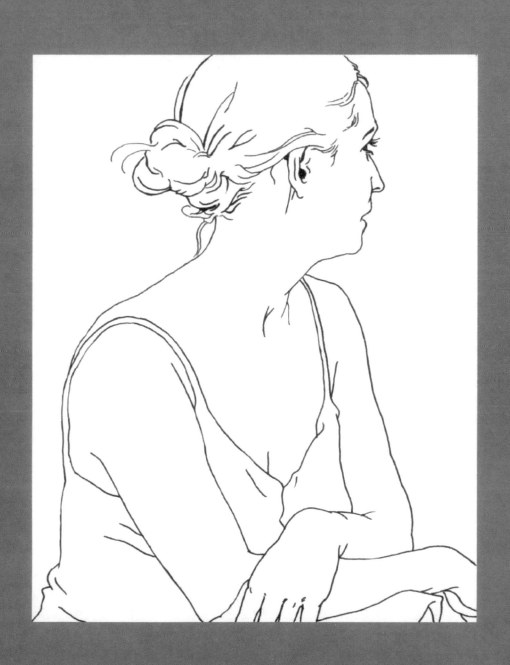

SEEING SHAPES

Once you have completed the copying exercise on page 14, you will be ready to tackle the task of drawing the same pose, but from an unfamiliar angle. The image has been inverted, encouraging you to look beyond the familiar. This exercise is just the beginning of your journey to discover a new way of seeing.

You will need

A QUIET PLACE FREE FROM DISTRACTIONS
AN ALARM CLOCK
A SHARP 1B PENCIL
TWO SHEETS OF A4 PAPER

Simply copy the lines and shapes as you see them, avoiding the temptation to try to see the figure upside-down

SEEING EXERCISE — DRAWING 2
3 minutes

1 Have another look at the drawing on the opposite page, now inverted.

2 Take your second sheet of paper and set the alarm for 3 minutes. Begin a second drawing, working quicker this time. Don't try to see a figure upside-down, just copy the shapes that you see, once again filling the sheet of paper as before. Remember, be strict with the 3 minutes but don't worry about completing the figure.

3 Remember to be disciplined and keep your attention only on the exercise in hand, rather than the result.

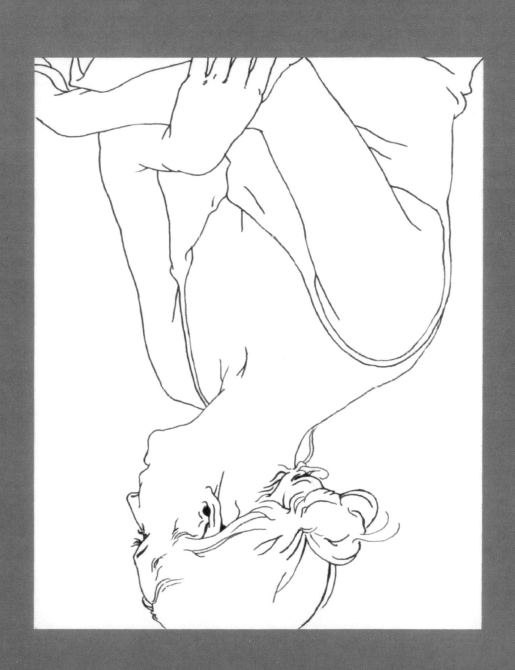

SEEING WORKSHOP

I have used the Seeing Exercise with hundreds of people and it still astounds me that the results are always the same. What we usually find is that the second drawing, or elements of it, look more convincing than the first. The shapes are more three-dimensional – the line is more confident and there is a more accurate expression of movement. Often the drawing is more complete – even though there was less time spent on it.

This is clearly illustrated in these examples of the Seeing Exercise that was undertaken by five participants on a workshop that I ran at Windsor Contemporary Art Fair. They are not chosen to be the best, but rather at random, demonstrating the improvements in confidence and expression that each individual experiences.

ASSESSING YOUR DRAWINGS
Take a moment to compare your own drawings. Does the second have a different, more expressive quality than the first? Once the drawing is inverted we have the chance to stop thinking 'arm' or 'shoulder', opening up the ability that we all have to really see the shape.

SEEING EXERCISE — DAVID POLE
David completed the same amount of the image even though there was less time for the second drawing. There is more 'solidity' to the figure in the second drawing – note the figure's right arm and especially the feeling of the neck turning and the roundness of the head shape.

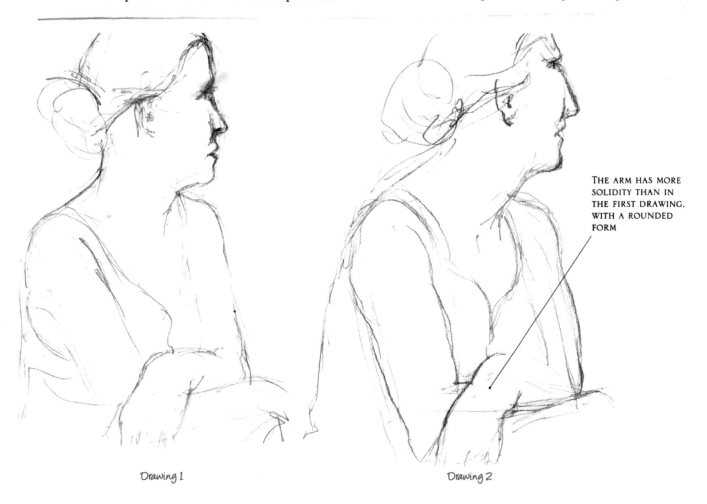

THE ARM HAS MORE SOLIDITY THAN IN THE FIRST DRAWING, WITH A ROUNDED FORM

Drawing 1

Drawing 2

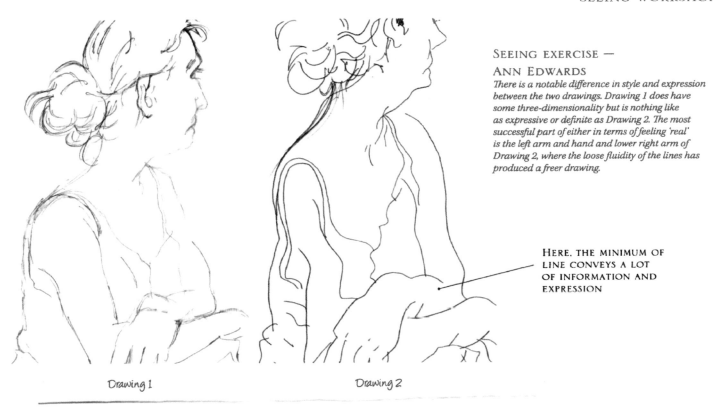

SEEING EXERCISE — ANN EDWARDS

There is a notable difference in style and expression between the two drawings. Drawing 1 does have some three-dimensionality but is nothing like as expressive or definite as Drawing 2. The most successful part of either in terms of feeling 'real' is the left arm and hand and lower right arm of Drawing 2, where the loose fluidity of the lines has produced a freer drawing.

HERE, THE MINIMUM OF LINE CONVEYS A LOT OF INFORMATION AND EXPRESSION

Drawing 1

Drawing 2

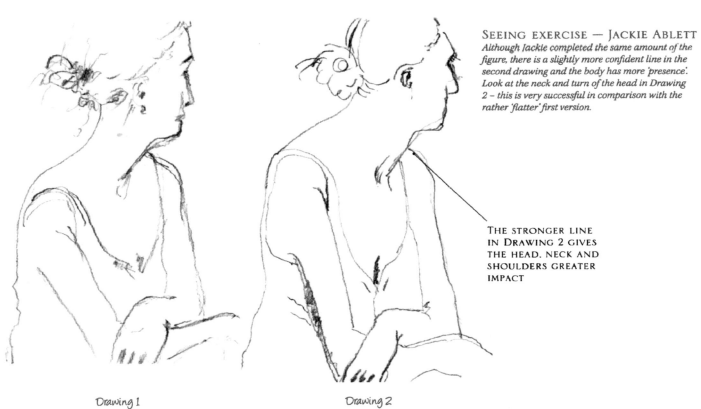

SEEING EXERCISE — JACKIE ABLETT

Although Jackie completed the same amount of the figure, there is a slightly more confident line in the second drawing and the body has more 'presence'. Look at the neck and turn of the head in Drawing 2 – this is very successful in comparison with the rather 'flatter' first version.

THE STRONGER LINE IN DRAWING 2 GIVES THE HEAD, NECK AND SHOULDERS GREATER IMPACT

Drawing 1

Drawing 2

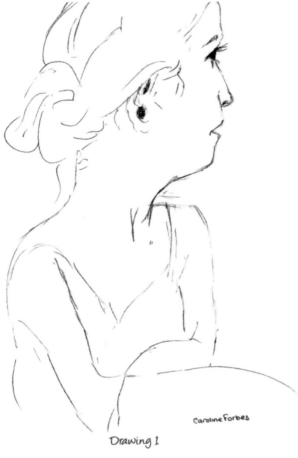

Caroline Forbes

Drawing 1

SEEING EXERCISE — CAROLINE FORBES

This example shows a big difference between the drawings. Drawing 2 is less complete but the line is drawn with much more confidence. The body of the second drawing is far more 'real' and the shapes more round. It also has a sense of the right arm being closer to the viewer than the left, giving it convincing three-dimensionality.

THE BODY IS RENDERED WITH MORE CONFIDENCE, ESPECIALLY THE PLACEMENT OF THE RIGHT ARM

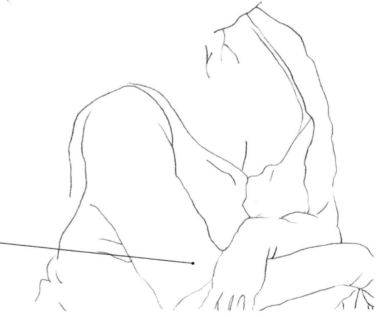

Drawing 2

SEEING EXERCISE — MARGARET HUGHES

Here, Margaret's second drawing is slightly fragmented and less complete than the first but the elements that have been rendered – hand, upper right arm and back of head – have more three-dimensionality than the first.

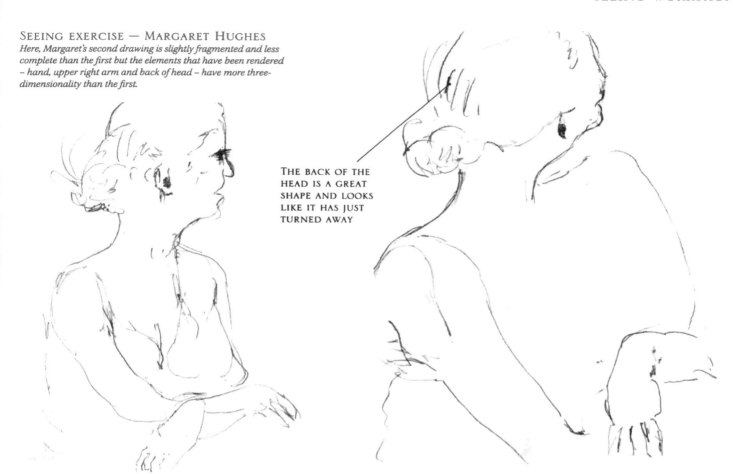

THE BACK OF THE HEAD IS A GREAT SHAPE AND LOOKS LIKE IT HAS JUST TURNED AWAY

Drawing 1

Drawing 2

SEEING IS BELIEVING

In some ways this is the only exercise that you need. It leads very simply and immediately to some of the essence of both the object of your attention and the magic of drawing itself. The problem we have is with all the things that get in the way of this 'real' seeing. We are all subject to many distractions: our busy chattering minds, telling us we're good or no good; our seeming lack of time in a fast-moving world; our tendency to want to find quick answers; our fears of 'getting it wrong', on and on and on. What can we do about it? The following exercises will help you to train your eyes to see more accurately, and give you the chance to draw the real essence of whatever is in front of you.

Left: An illustration commissioned for a book called The Flying Squirrel and Other Woodland Stories, *published by Peter Lowe/Eurobooks Ltd, 1995.*

'To empty one's mind of all thought and refill the void with a spirit greater than oneself is to extend the mind into a realm not accessible by conventional processes of reason.' EDWARD HILL, 'THE LANGUAGE OF DRAWING'

DRAWING FROM SILENCE

HAVE YOU EVER CONSIDERED HOW MANY THOUGHTS WE HAVE DURING ONE DAY? HUNDREDS? THOUSANDS? WE THINK A LOT. THOUGHTS ABOUT THIS AND THAT, WHAT WE HAD FOR BREAKFAST, WHAT HAS HAPPENED, WHAT MIGHT HAPPEN, THIS FRIEND, THAT PROBLEM, ARE WE DOING THE RIGHT THING, ARE WE NOT? ON AND ON AND ON. FINDING SOME PEACE FOR ALL YOUR SENSES WILL INEVITABLY HELP WITH YOUR DRAWING TOO.

As demonstrated in the exercises on pages 14–21, too much thinking can prevent real seeing. We could extend that idea to suggest that thinking is limited whereas the ability to see is limitless. Real seeing requires some quality attention, free of thoughts. To help you to achieve this you need to complete the Sense Exercise opposite. This is a short exercise that I use during my own creative process to isolate the senses to achieve a pure level of attention, reducing the temptation to over-think and over-do and thereby improving your vision.

Right: The Meditating Hippogriff.

You will need

A QUIET PLACE FREE FROM DISTRACTIONS
AN UPRIGHT DINING CHAIR

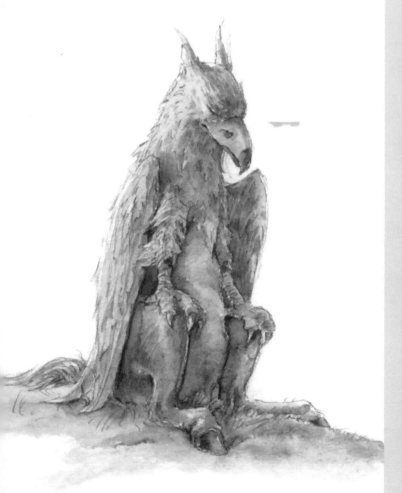

SENSE EXERCISE

2 minutes

This exercise is probably the most important in the whole book. Make it your passion to do it it *before* every drawing session and every time you feel your mind wandering. With continued practice you will be amazed at the difference it will create in your attention, creativity and quality of drawing.

1. Sit upright on a dining chair (*not* an armchair) so that both feet are on the ground, legs uncrossed and hands resting in your lap.

2. Close your eyes and bring your attention to the feeling of your body in the chair and your feet on the ground. Be aware of any tension and allow it to fall away. Rest for a few moments and be aware of where your thoughts are.

3. Turn your full attention to the feeling of the air across your face and allow yourself to experience the subtlety of that feeling. If you notice that your thoughts are wandering, return your attention to the air on your face.

4. Shift attention now to your sense of smell and fully absorb all the scents that surround you. Notice that the breath passing in through your nostrils is cooler than that which passes out.

5. Finally bring your full attention to listening. First, hear the sounds within the room without judging or naming them. Gradually allow your listening to extend outside the immediate room, encompassing every sound that you hear, even the most distant and gentle.

6. Let those sounds simply rise and fall from the silence where they originated. Rest for a few moments just listening. Listen deeply.

7. Bring yourself back by gently opening your eyes and resting attention on your vision. Allow the forms and colours to come to you rather than thinking about seeing them. You're now ready to draw.

SEEING THE BIGGER PICTURE

IN ORDER TO HELP US TO SEE BEYOND THE IMMEDIATE AND USE ALL OF OUR SENSES, WE NEED TO BEGIN LOOKING AT DIFFERENT WAYS TO USE THE FULL POTENTIAL OF OUR EYES. CONSIDER ONE OF YOUR OTHER SENSES, LET'S SAY HEARING. CAN YOU RECALL A SOUND THAT YOU ASSOCIATE WITH A PARTICULAR PLACE OR TIME IN YOUR LIFE, FOR EXAMPLE, A PIECE OF MUSIC? YOU MAY HAVE NOTICED THAT HEARING THAT SOUND AGAIN IS OFTEN MORE EVOCATIVE THAN A VISUAL IMPRESSION OF THE MEMORY, SUCH AS A PHOTOGRAPH. YOUR SENSE OF SMELL IS THE SAME. MY FEELING IS THAT WE HAVE A HUGE UNTAPPED RESERVOIR OF WAYS TO SEE MORE ACCURATELY.

USING ALL YOUR SENSES

Practising owl vision will help you develop an ability to perceive patterns, such as the gentle swaying of trees, and that which breaks the pattern, for example a bird flitting. The observation of such patterns will help develop your sense of composition. Your eyes will also attune to the slightest movement. Anything which allows you to see movement faster will be invaluable.

I learned the owl exercise (see tip below) from Tom Brown, a tracker and wilderness teacher from the USA. It is called wide, splatter or owl vision. North American Indians would use this exercise to read movement within a landscape. The practice of it will fine-tune your vision and allow you to perceive an extraordinary amount of hitherto unseen detail.

Bigger-picture vision will help you to see the overall before gradually homing in on the detail.

Tip

STAND OR SIT FACING STRAIGHT AHEAD AND KEEP YOUR EYES FOCUSED ON A SINGLE POINT. EXTEND YOUR ARMS OUTSTRETCHED AT YOUR SIDES. WIGGLE YOUR FINGERS AND SLOWLY MOVE YOUR ARMS BACKWARDS AND FORWARDS, SOFTENING YOUR VISION OF THE WHOLE SCENE AT THE SAME TIME BUT KEEPING YOUR HEAD STILL. NOTE THAT YOU CAN STILL SEE YOUR FINGERS MOVING WHEN YOUR HANDS ARE AT THE LIMIT OF THE 180 DEGREE ARC OUT IN FRONT OF YOU.

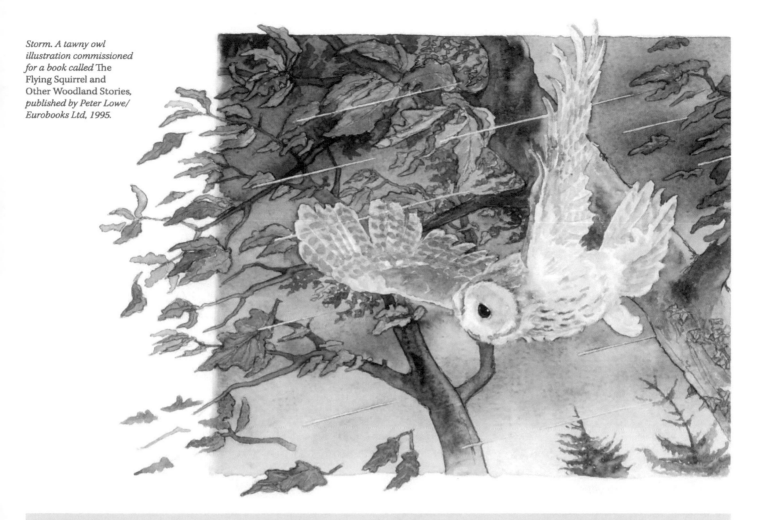

Storm. A tawny owl illustration commissioned for a book called The Flying Squirrel and Other Woodland Stories, *published by Peter Lowe/ Eurobooks Ltd, 1995.*

Owl vision exercise

At least 10 minutes

Practise the technique of extending your visual awareness as described in the tip opposite, then test it out in the wild. The longer you practise, the more you will notice. Spend at least 10 minutes the first time you try it.

1 Head off to a landscape or a park where there are some trees. Identify a focus point in the distance or on the horizon. Keeping your eyes on that point with your head and body very still (breathe slowly), allow your eyes to soften to the 180 degree arc. Your vision will become a little fuzzy because you are not concentrating on detail.

2 You will start to notice all kinds of subtle movements over the periphery of your vision; the grass moving in the breeze, a bird flying, trees swaying, insects being. Your peripheral vision is more attuned to picking up movement and you'll begin to see far more than when you first looked.

3 If you persist you may find yourself becoming very relaxed and your other senses improving. With time and practice you may pick up the tiniest of movements, such as a rabbit blinking. You may also notice that animals and birds begin to come closer to you as your presence softens. This applies to other humans too!

4 If you notice something of interest you can always switch to 'normal' vision to check it out. Beware though, keep your movements slow so that you don't disturb or startle the object of your attention.

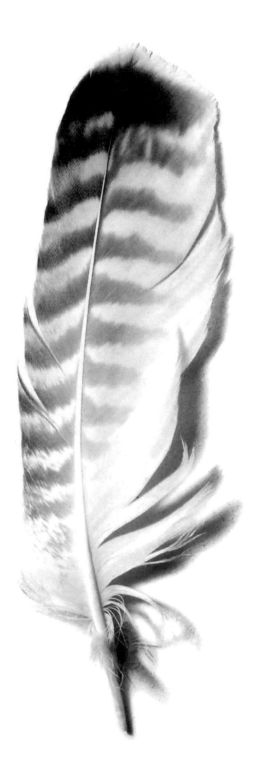

LEARNING TO OBSERVE

HAVING PRACTISED THE SEEING EXERCISE ON PAGE 14, YOU'LL HAVE A SENSE OF HOW WE ALL SEE AND DRAW WHAT WE THINK IS THERE RATHER THAN WHAT IS REALLY IN FRONT OF US. IMPROVING THE WAY WE SEE IS OBVIOUSLY THE ANSWER, BUT HOW? THE FOLLOWING WILL SET UP A SITUATION WHERE YOU WILL HAVE TO FOCUS ON TRUE LOOKING — IT COMES FROM MANY YEARS OF EXPERIENCE AND OBSERVATION OF HOW WE LOOK AT THINGS.

See it as a practice, not as a means to an end and practise it as much as you can. The wording of the instructions is very important. Please follow them very carefully but also have fun with the process and thereby divert your attention away from the result – it will give your drawings a chance to really live and breathe. I cannot emphasize the value of this exercise enough – words will not suffice!

OBSERVATION EXERCISE

10 minutes

Now you need to find a feather. Make sure it's a wing or tail feather like the example shown which is a tail feather from a buzzard. For the purposes of this exercise, you can ignore the detail of the pattern and colour. Using a crow feather, for example, which is uniformly black would make this easier!

Tip

INITIALLY, YOU MAY BE STRUGGLING WITH THE TEMPTATION TO LOOK DOWN WHILE YOU DRAW. TO COMBAT YOUR NATURAL CURIOSITY, YOU MAY FIND IT HELPFUL TO DRAW UNDERNEATH A SEPARATE SHEET OF PAPER HELD BELOW YOUR EYES TO BLOCK OUT THE DRAWING.

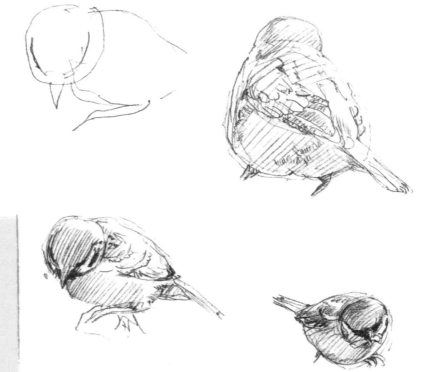

You will need

A QUIET PLACE FREE FROM DISTRACTIONS
AN UPRIGHT DINING CHAIR
AN ALARM CLOCK
A SHARP 1B PENCIL
AN A3 PAD OR SHEETS OF PAPER
A FEATHER

1 **Drawing 1**
Place the feather in front of you on the table and do a strict 3-minute sketch. Now put that drawing aside and be ready to start another.

2 **Drawings 2, 3 and 4**
Begin your preparation for the next drawing by picking up the feather and spending a few minutes looking at it in as many different ways as you can think of, concentrating on the outline and form.

3 Try to look at it as if it's the first time you've seen a feather. Be passionate about this. Use all your senses and your imagination. For example, can you see it with your ears and nose? What does it feel like? What does it remind you of? What would it feel like to *be* this feather? Set the feather down at a different angle from the first drawing, keeping it at arm's length from your paper.

4 Close your eyes and take yourself through the Sense Exercise on page 23. When you open your eyes, allow your vision to rest on the feather in front of you. Once again, pay particular attention to the outline, the quill and the shape. Use your full, relaxed attention without thinking about it. See it as if for the first time.

5 Begin drawing but never take your eyes off the feather. Simply allow your hand to follow what your eyes see. It is crucial that you don't look down at your drawing during this exercise. Even if you take one quick glance at the paper, begin a new one. You will need to be honest with yourself here!

6 Be interested in the object, not the drawing. Enjoy feeling the movement of pencil on paper, free from the desire to produce a good drawing. Draw quickly so that you have less chance to think. Complete three drawings in quick succession.

OBSERVATION WORKSHOP

It is always helpful and informative to look at examples of other artists' work and I have included here some of the drawings produced by students at a recent workshop. Each artist has an individual style but faced with completing the Observation Exercise, it is interesting to note the similarities in how each of their drawings becomes looser and more expressive as they progress. The examples shown here may mirror the changes that you have experienced.

ASSESSING YOUR DRAWINGS

Once you have completed the Observation Exercise, take a few moments to really see each of your drawings; then compare the last three drawings where you only looked at the feather with the first one you completed while looking at the paper. It may help to invert your drawings to see them as if for the first time – sometimes the obvious is not easily observed! We can look

at our drawings in the same way that we see objects – falling into the trap of seeing what we think we see. Look *closely*. You should begin to notice that the progression has been from a rather mechanical, flat shape to something more expressive that captures some of the movement and three-dimensional quality of the subject.

Whatever the success or not of your completed drawings, there will be some lines, or parts of lines, which look 'right' and 'feel' feathery. Usually, these are the parts of the sketch that we can't even remember drawing! There will be a quality or character to these lines which is almost impossible to achieve when drawing conventionally. In the desire to create a perfect drawing every time, these 'magical' moments can easily be overlooked but they are priceless in the real development of your creativity.

OBSERVATION EXERCISE — KATHRYN JORDAN
Buzzard feathers are particularly fine and some of that quality has started to appear in Kathryn's drawings completed without looking. They are very much more expressive and have a sense of movement and life.

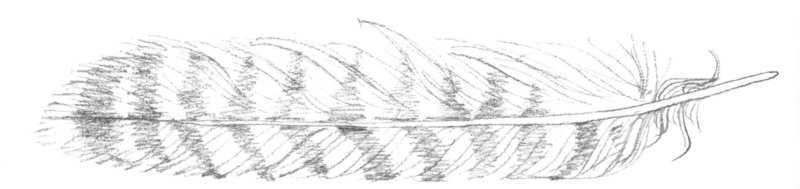

Kathryn's first feather drawing made by looking as she was drawing. An accurate rendition (although forgetting to ignore the pattern!) but fairly lifeless and flat.

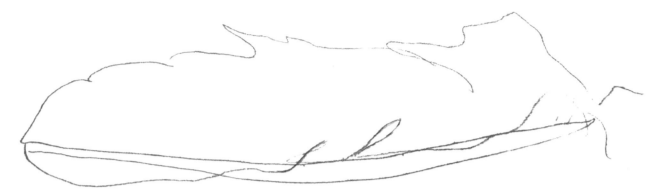

Clearly a much looser, less accurate drawing than the first one. If we can go beyond the need for accuracy, we might also say that it's more expressive and has a certain sense of movement.

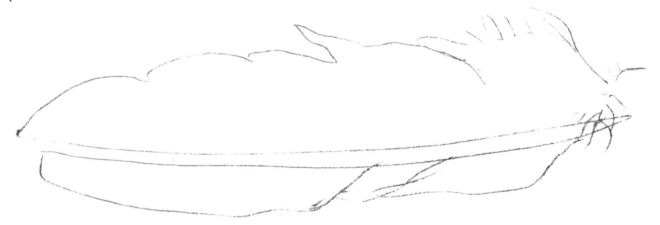

A bit more accuracy has crept in here with the outline beginning to 'feel' feathery. This also conveys a sense of something three-dimensional sitting in space, both in the direction of the stem and across its opposite plane from edge to edge.

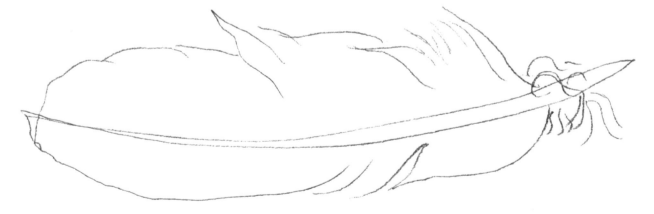

A good example of how complete a drawing can be with such simple lines. It's clear that Kathryn is becoming relaxed with the idea of not looking while drawing, as you can read in the confidence of her line. Immediately evident is the increased accuracy but, more importantly at this stage, there is a real feeling of shape, movement and softness.

Feathers

A weightless bond of hidden words
whispers a soaring song
which climbs across the mist
to a land where flight belongs

Alight all creatures of air and wind
arise in shards of light
Your destiny lives in the sky
to lift our earth-bound sight

to remind us that this life
will fall and pass us by
to remind us that the air we breathe
also helps you fly

I wait with palms face upward
in case you drop a hair
For by catching a piece of your flight
I too can taste the air.
NATHALIE BREWER

VARIATIONS

To extend this exercise you can complete as many drawings
as you like. Change the position of the feather each time and
the speed that you draw – try some fast and some slower.
Try keeping your pencil in contact with the paper all the way
through the drawing and build up your confidence and trust in
not looking down. Have fun with this but always keep your full
attention on really seeing the feather.

OBSERVATION EXERCISE — CLIFF WRIGHT

*These are my own attempts at completing the same exercise. Note the progression
– I speeded up on all three drawings that were made without looking. I'm
especially interested in the last (the quickest) which has taken on an almost
landscape-scale quality of three dimensions. In comparison with the first 3-
minute sketch, it is more abstract and could be seen as a drawing of rolling hills
receding into the distance.*

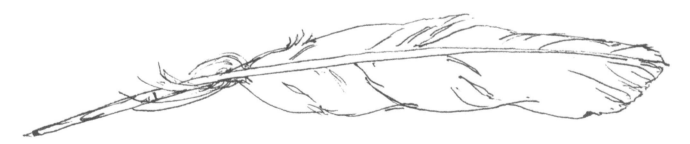

The first of my drawings made with looking at the page is a fairly accurate attempt. There is some sense of the featheriness and it has a
three-dimensional feel

The first drawing without looking has become a lot more free. Some of the accuracy has gone but you can feel the speed of the marks and how they are a little more successful at conveying shape.

Again without looking, the lines are freer still but now show a real sense of three dimensions. Note how the top line of the shape appears further away in space than that of the stem and how the bottom line is closest of all. Note too, that this is true in spite of the relative strengths of the three lines. Normally a harder line will look closer than a soft line, but here it is not the case.

The final drawing is pleasing because of its real sense of depth from top to bottom. The expressive nature of the line conveys a feather in a very few marks but it could equally be a much larger object, like a landscape.

DISCIPLINE LEADS TO FREEDOM

DOES THIS SOUND DULL TO YOU? TOO MUCH LIKE HARD WORK? DOES IT SOUND LIKE SOMETHING YOUR PARENTS MIGHT HAVE NAGGED YOU ABOUT? LET'S THINK OF WHAT FREEDOM MEANS IN THE CONTEXT OF THIS BOOK. IT IS THE ABILITY TO SEE BEYOND OUR INITIAL IMPRESSIONS TO A MORE ESSENTIAL TRUTH, THROUGH THE ACT OF DRAWING. IT IS TO RISE ABOVE THE LIMITATIONS OF THOUGHT AND TO SOME EXTENT BE FREE OF OURSELVES, SO AS TO RECOGNIZE OUR INCREDIBLE CREATIVE ABILITIES. MOST ARTISTS HAVE EXPERIENCED BEING 'IN THE FLOW', WHERE CREATIVITY SEEMS EASY AND FREE AND STEPPING OUT OF THE WAY SEEMS TO BE ALL THAT'S REQUIRED.

How about the word 'discipline'? The connotation here is usually of something strict and off putting, even severe. Consider this definition from an Indian holy man, Shri Shantananda Saraswati: 'The meaning of discipline is to flow freely, to retain balance and touch nothing.'

Through your drawing, the meaning of those words can be experienced directly and immediately – not a bad incentive! So it's worth setting up some regular practices, which will give you a fighting chance of achieving the extraordinary. Here are just a few suggestions that I've found useful:

• **Practise something, for example the Observation Exercise, for 10 minutes every day.** Even in our busy everyday lives it is possible to find 10 minutes to re-focus our attention. Allow yourself to become totally absorbed and not lost in thought. Keep a record of your progress.

• **Identify something that happens regularly throughout the day, such as the phone ringing.** Use that 'trigger' to remind yourself to really look and be present; in other words, to look without thinking.

• **Acknowledge how much time you have before you begin drawing.** This sounds obvious but in the enthusiasm to begin it is easily overlooked. If you only have 5 minutes then it is pointless to try to complete a detailed study. Wait until you have an hour or two; it will help you avoid the frustration of rushing your drawings.

• **Draw your favourite things.** My fascination is with all things from nature, yours may be different. What is it that really excites you? Draw that, over and over, until you realize that you never really knew it at all!

• **Then challenge yourself. What are the things that you struggle with?** Faces? Hands? Then draw those, firstly without looking at the paper. Force yourself to really see – forget the label, just see the shapes. Draw over and over again until you realize that the idea that you couldn't do it was just a figment of your imagination.

• **Be persistent or even stubborn. Some days drawing is a real struggle.** Hopefully, using the exercises in this book, it will become easier and more and more relaxing. Until that happens you may have to just accept the difficulty and battle through it – that too is a useful process. Build up your determination to succeed!

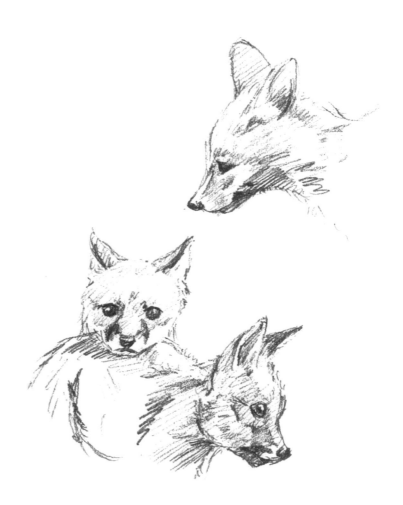

'We must always work and a self-respecting artist must not fold his hands on the pretext that he is not in the mood. If we wait for the mood, without endeavouring to meet it half way, we easily become indolent and apathetic. We must be patient and believe that inspiration will come to those who can master their disinclination.' PYOTR ILYICH TCHAIKOVSKY (1840–1893)

'The day is coming when a carrot, freshly observed, will start a revolution.' Paul Klee (1879–1940)

Do something new

THE MAIN AIM OF THIS FIRST SECTION IS TO FIND DIFFERENT WAYS OF SEEING THINGS. IF YOU'VE COMPLETED THE EXERCISES UP TO THIS POINT YOU WILL HAVE A GOOD IDEA OF HOW LIMITED OUR VISION CAN BE. I HOPE YOU WILL ALSO HAVE A SENSE OF THE VAST RESERVOIR OF POTENTIAL THAT LIES WITHIN US, FOR THE MOST PART HIDDEN AWAY. TO TAP INTO THAT RESERVOIR REQUIRES SOME EFFORT, IN FACT IT DEMANDS A CONSTANT DESIRE TO ENJOY CHALLENGING YOURSELF AND YOUR IDEAS. A USEFUL WAY TO 'SEE' YOUR DRAWING, ESPECIALLY WHEN YOU PRACTISE, IS TO TRY SOMETHING NEW WITH EVERY DRAWING YOU DO. WHEN RETURNING TO MORE CONVENTIONAL DRAWING, THESE RULES STILL APPLY.

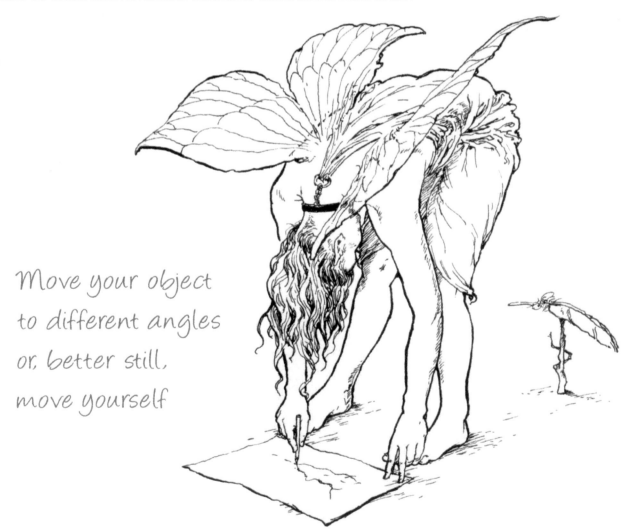

Move your object to different angles or, better still, move yourself

This is obviously easier to do if you're having a bad drawing day. If our drawings are going well then there will be less desire to change. But seeing well is about seeing something as if for the first time, every time. To help you in this task, complete the Observation Exercise on page 27, then ask yourself these four basic questions:

• do I start my drawing from the same place on the object every time?
• am I always looking from the same angle?
• do I always draw at the same speed?
• are my drawings always the same size?

BREAKING OLD HABITS

Old habits can be difficult to break, so here are a few ideas to help you develop a desire to transcend them.

• **Start each new drawing from a new place.** If you always begin at the top, try the bottom or middle. You may have experienced some difficulty in retaining correct proportion when drawing without looking at the paper or with the upside-down figure. This may happen again and again. Simply starting from a different place each time may rectify this problem.

• **Change the angle from which you observe the object – this is fundamental to looking differently.** Either move the object around or, better still, move yourself. The possibilities are endless!

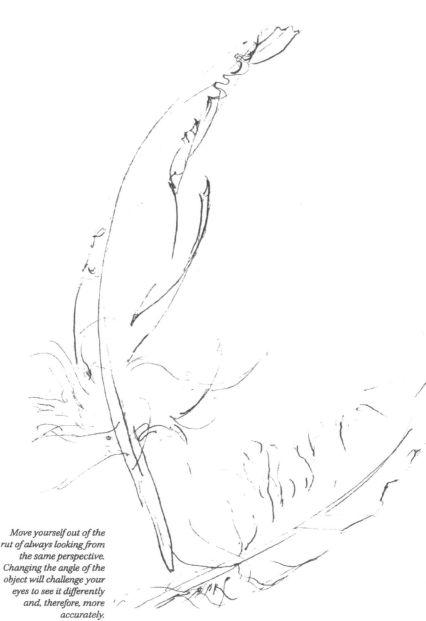

Move yourself out of the rut of always looking from the same perspective. Changing the angle of the object will challenge your eyes to see it differently and, therefore, more accurately.

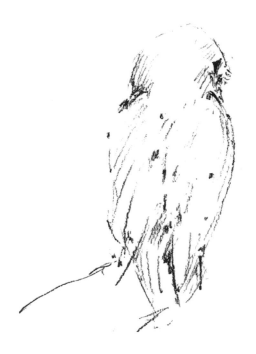

• **Set yourself challenges for timed drawings.** When you're not looking at the paper, most of your drawings will be a matter of just a few seconds – especially if you're new to it. Continue to practise by extending or shortening your times and, say, do six drawings at 10 seconds or 30 seconds or a minute.

• **Invent your own rules and look for patterns to break.** For instance, if you struggle to keep focused on longer drawings then gradually build the timings up – be easy on yourself and build up slowly.

• **Change the scale. Most of us end up drawing on the same scale each time.** Have a look at the feather drawings you completed for the Observation Exercise. Are they all roughly the same size? Experiment by drawing something that is tiny on as large a scale as possible – or something large as a small drawing.

Tip
DON'T BE AFRAID TO FILL YOUR SHEET OF PAPER — GO RIGHT TO THE EDGES!

• **Hold or observe your object closer to or farther away from yourself.** This is a very easy way to alter the size of your drawings as you are more likely to create a larger image if the object is close up.

• **Alternatively, you could try drawing an invisible sketch using just your finger, tracing the outline on your paper to approximately the size you'd like to achieve.** Trace this new scale three or four times, then do your drawing. With practice this should encourage your brain to familiarize itself with the change in size.

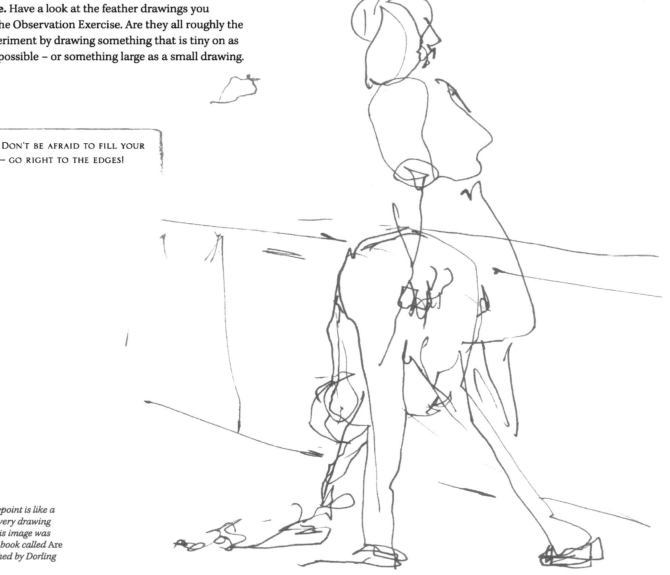

Left: A different viewpoint is like a fresh start – make every drawing a new beginning. This image was commissioned for a book called Are you Spring?, *published by Dorling Kindersley, 2000.*

USING YOUR OTHER HAND

I HAVE SEEN MANY, MANY TIMES ON WORKSHOPS THAT SWAPPING HANDS CAN OFTEN UNLEASH CREATIVITY. I'VE ALSO OBSERVED THAT IT SEEMS TO WORK WHETHER OR NOT YOU ARE RIGHT- OR LEFT-HANDED. WHEN WE'RE LOOKING FOR DIFFERENT WAYS TO SEE, OFTEN THE SHOCK OF DOING SOMETHING NEW CAN PRODUCE THE DESIRED EFFECT. DRAWING WITH YOUR OTHER HAND CAN SEEM ODD AT FIRST. YOU MAY FIND THAT YOUR LINE IS MORE FREE AND YOUR DRAWINGS MORE EXPRESSIVE. OCCASIONALLY THEY WILL EVEN BE MORE ACCURATE.

Follow the exercise below, changing hands as often as you like. You'll find it is a great way to see both the object and yourself differently. As you recognize this new-found freedom, see if you can bring that knowledge back into your 'normal' hand.

You will need

- A QUIET PLACE FREE FROM DISTRACTIONS
- AN UPRIGHT DINING CHAIR
- AN ALARM CLOCK
- A SHARP 1B PENCIL
- A PAD OR SHEETS OF PAPER (NO SMALLER THAN A3)
- A FEATHER

CHANGING HANDS EXERCISE
10–15 minutes

1 Observe the feather and sketch with your normal drawing hand.

2 Complete the Sense Exercise (see page 23) and sketch the feather again without looking at the paper. This time draw with your other hand and pay very close attention to how different it feels. Persist past the 'strangeness' and see if you can feel a sense of freedom. Keep changing hands for each drawing.

3 Examine the differences between these drawings and those of your 'normal' hand. There will tend to be less concern about producing a final drawing because of course, you have little or no experience with your other hand. Interestingly, your drawings may also be larger with the non-dominant hand.

CHANGING HANDS EXERCISE — MARY PARNWELL
(RIGHT-HANDED)
With her normal drawing hand, Mary has interpreted the feather with a continuous line, conveying detail. However, when she changes to her left hand, the drawing, although on the same scale, is more expressive and free, more feather-like and less 'flat'.

Right hand

MARY'S ABSTRACT
SHAPES SUGGEST
THE FEATHER'S
FORM

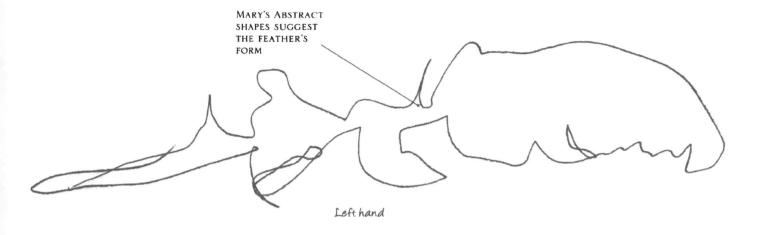

Left hand

CHANGING HANDS EXERCISE — SOPHIE MILLER
(RIGHT-HANDED)

These were all very fast sketches, and you get a sense of that from the swift, fleeting lines. When Sophie changed to her left hand, the drawing was rendered almost twice the size but it also describes a more three-dimensional shape – even though the line is broken and incomplete.

THE LEFT-HANDED
DRAWING IS ON A
LARGER SCALE BUT
WITH MORE FORM
AND EXPRESSION

THE RIGHT-
HANDED
DRAWINGS ARE
UNIFORM IN SIZE

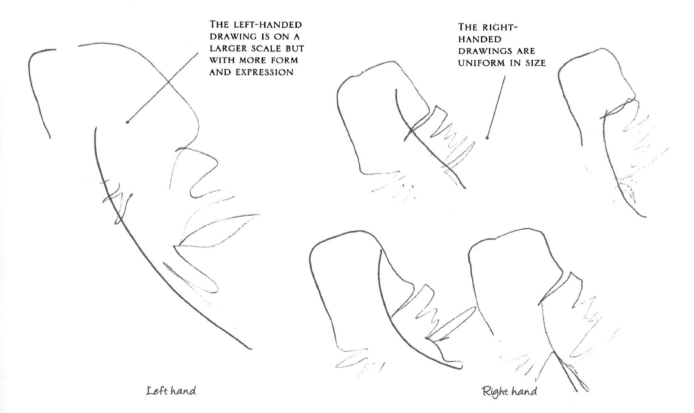

Left hand

Right hand

'...the beautiful lines insisted on being traced – without weariness. More and more beautiful they became, as each rose out of the rest, and took its place in the air. With wonder increasing every instant, I saw that they 'composed' themselves, by finer laws than any known to men. At last, the tree was there, and everything that I had thought before about trees, nowhere.' JOHN RUSKIN (1819—1900), AFTER IDLY DRAWING AN ASPEN TREE

DRAWING FROM MEMORY

DEVELOPING YOUR ABILITY TO DRAW FROM MEMORY IS A USEFUL SKILL AND A GREAT WAY TO IMPROVE YOUR VISION. THERE WILL BE OCCASIONS WHEN YOUR PAPER AND PENCIL JUST AREN'T AVAILABLE BUT YOU DESPERATELY WANT TO RECORD WHAT YOU'VE SEEN — PERHAPS AS A REFERENCE FOR A PAINTING.

You will need

FOR MEMORY EXERCISE 1:

A QUIET PLACE FREE FROM DISTRACTIONS

AN UPRIGHT DINING CHAIR

AN ALARM CLOCK

A SHARP 1B PENCIL

A PAD OR SHEETS OF PAPER (NO SMALLER THAN A3)

A FEATHER (IDEALLY THE SAME AS THE ONE USED FOR THE EXERCISE ON PAGE 27)

FOR MEMORY EXERCISE 2:

A TREE, CLOSE TO YOUR HOUSE OR NEXT TO SOMEWHERE THAT YOU CAN COMFORTABLY SKETCH

MEMORY EXERCISE 1

5 minutes

1 Spend two minutes holding the feather still in front of you and observing it closely, with your *full attention*.

2 Close your eyes and see if you can still see the image of your feather in your mind's eye. If that's the case then complete a drawing with your eyes closed.

3 If two minutes looking wasn't long enough, look again until you have the mind's eye image.

Tip

CONTINUED PRACTICE WILL BUILD YOUR ABILITY TO RECALL IMAGES OR SCENES AT A LATER DATE AND YOU MIGHT BE SURPRISED AT THE RESULTS!

MEMORY EXERCISE 2

30 minutes

Here's another idea to help train your visual memory on a larger scale.

1 Find a tree – choose one that is either *very* close to your house or next to somewhere that you can sketch. Choose a simple tree – one that is not overwhelmed with leaves and detail – where you can see the branch structure, such as a silver birch.

2 Sit close by the tree at an angle that attracts you. Complete the Sense Exercise on page 23, then spend at least 20 minutes looking at the tree. Allow yourself to be free of distraction by focusing your attention and using the time wisely. Don't try to count branches. See the overall shape then gradually focus in on detail. Use owl vision (see page 25).

3 See the tree in as many different ways as you can think of, use your imagination as well as the information in front of you. How does it make you feel? If it were a person, what kind of character would it be?

4 After 20 minutes, move away from the tree and return to your drawing board – *keep your attention*. Begin sketching the tree from memory. Stop drawing when you're starting to guess what was there (usually this occurs after only a few minutes!).

5 Take your drawing back to the tree and compare. What did you notice? What did you miss? It's easy to feel disappointed if you didn't capture as much as you thought you would. Don't worry, this is not about creating a masterpiece. Have another go and be excited by the challenge of trying to perceive that which we normally overlook. You may never look at a tree in the same way again!

MEMORY EXERCISE — SAMIRA HARRIS

This is a great rendition of the tree shown in the photograph. As with all the exercises in this part of the book, we are not looking for correct proportions as a final result. An accurate portrayal of every twig would have been impossible since Samira only spent around 15 minutes on the sketch. Even so, the accuracy that she has achieved is remarkable, given that she drew while not looking at the tree. She chose her tree well, since it has a very distinctive character.

Have a closer look now at the quality of the marks on the drawing, and you can see something deeper. See how the dark, hard lines of the trunk contrast with the light, almost feathery traces of finery at the end of the branches and how those opposites balance each other. Then consider the 'feeling' of character, like a wizened old grandfather, that she has managed to suggest.

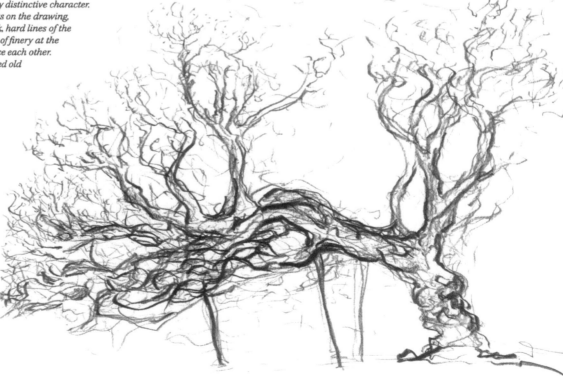

LOOKING DEEPER

WITH THE ATTENTION YOU'VE GIVEN TO YOUR VISION SO FAR, YOU SHOULD FIND THAT YOUR ABILITY TO SEE THAT WHICH IS 'REALLY' THERE IS IMPROVING. WE CAN ALWAYS LOOK MORE ACCURATELY THOUGH. USE THIS TWO-PART EXERCISE TO FINE-TUNE YOUR EYESIGHT EVEN FURTHER. YOUR FEATHER IS FESTOONED WITH SUBTLE CURVES AND FINE LINES WHICH ARE BARELY DISCERNABLE AT FIRST GLANCE — THAT IS WHY IT'S A GREAT OBJECT TO PRACTISE ON. CHALLENGE YOURSELF TO EXPLORE HOW MUCH OF THIS YOU CAN SEE AND FEEL; THEN LET THE DISCIPLINE OF THE EXERCISE AND YOUR PENCIL DO THE REST.

We will talk more about drawing from life later in the book but for now enjoy experimenting. Continue to practise as many times as you like – change hands, play with different timings, use different angles and different-sized drawings.

You will need

A QUIET PLACE FREE FROM DISTRACTIONS

AN UPRIGHT DINING CHAIR

A SHARP 1B PENCIL

A PAD OR SHEETS OF PAPER (NO SMALLER THAN A3)

A FEATHER

Sophisticated shape, as well as movement, is possible with a relatively simple technique

LOOKING DEEPER EXERCISE
20–25 minutes

Complete the Sense Exercise (see page 23).

1 PART 1: Begin your drawing by looking only at the feather – not your paper. As you progress be very attentive and wait until the first moment of wondering where you are on the drawing. At that precise point take the quickest of glances down at the paper to check your position. The danger is that you will revert to 'trying' to create the drawing so keep your attention on just seeing the feather! Use two per cent of your time to continue making rapid glances only when you're struggling for position.

2 PART 2: Now half-close your eyes. Make this a gentle movement – don't squint, keep the eyes relaxed. Notice that the detail now becomes fuzzy and that it's easier to see where the outline of your feather is dark against the background and where it is lighter. There may even be some areas where your feather virtually dissolves into the background. As you draw, keep your eyes half-closed and reflect the differences by pressing harder or lighter accordingly. Simply allow your hand to follow what your eye sees.

3 Draw quickly and employ all of your attention. You may like to try this with more complex subjects, for example your hand, faces or figures.

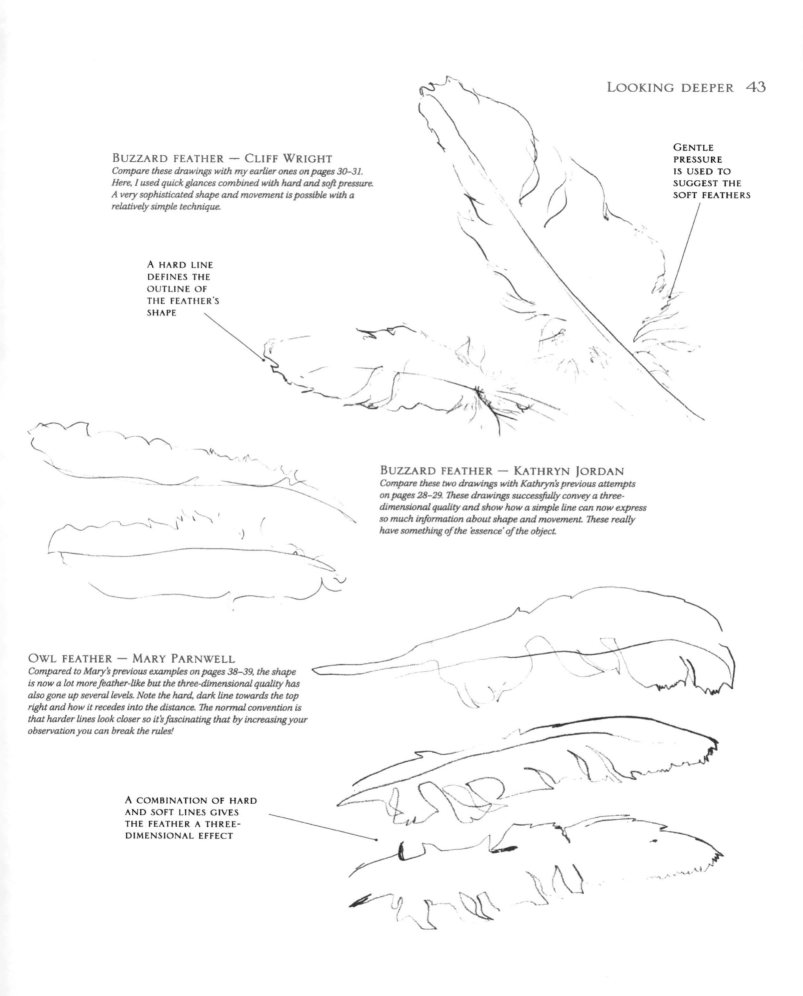

BUZZARD FEATHER — CLIFF WRIGHT
*Compare these drawings with my earlier ones on pages 30–31.
Here, I used quick glances combined with hard and soft pressure.
A very sophisticated shape and movement is possible with a
relatively simple technique.*

GENTLE
PRESSURE
IS USED TO
SUGGEST THE
SOFT FEATHERS

A HARD LINE
DEFINES THE
OUTLINE OF
THE FEATHER'S
SHAPE

BUZZARD FEATHER — KATHRYN JORDAN
*Compare these two drawings with Kathryn's previous attempts
on pages 28–29. These drawings successfully convey a three-
dimensional quality and show how a simple line can now express
so much information about shape and movement. These really
have something of the 'essence' of the object.*

OWL FEATHER — MARY PARNWELL
*Compared to Mary's previous examples on pages 38–39, the shape
is now a lot more feather-like but the three-dimensional quality has
also gone up several levels. Note the hard, dark line towards the top
right and how it recedes into the distance. The normal convention is
that harder lines look closer so it's fascinating that by increasing your
observation you can break the rules!*

A COMBINATION OF HARD
AND SOFT LINES GIVES
THE FEATHER A THREE-
DIMENSIONAL EFFECT

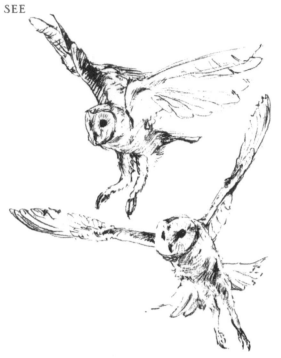

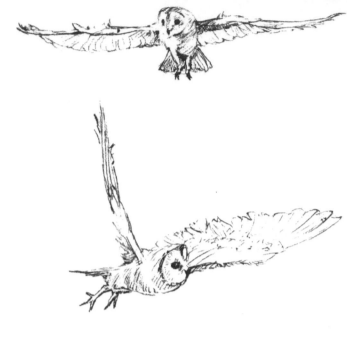

CAPTURING MOVEMENT

CONTINUING TO DEVELOP THE ABILITY OF YOUR EYES LEADS ME TO LOOK AT MOVING SUBJECTS. HOW CAN A STILL, FLAT IMAGE EVEN BEGIN TO REPRESENT THE SUBTLE FLUIDITY AND SPEED OF A FIGURE IN MOVEMENT? IN THE THIRD PART OF THIS BOOK WE'LL TALK ABOUT THE DEVELOPMENT OF A CHARACTER AND CONTROLLING THE WAY IT MOVES. FOR PRACTICE HERE WE WILL STAY WITH OBSERVATION. ASK YOURSELF HOW IT WAS THAT BEFORE THE INVENTION OF THE CAMERA, LEONARDO DA VINCI SAW THAT THE MOVEMENT OF A BIRD'S WINGS IS NOT SIMPLY UP AND DOWN BUT DESCRIBES A FIGURE OF EIGHT. HIS SPEED OF SIGHT WAS EXTRAORDINARY NO DOUBT BUT, AS MENTIONED BEFORE, I BELIEVE THAT THE POTENTIAL TO SEE MORE RESIDES IN ALL OF US.

It is one thing to observe movement and quite another to freeze it on the page. Many attempts will end in apparent failure and it's easy to lose hope. It all depends on the way you see your drawings. Learning to see well is also about learning to discern the quality of line. If you've practised the feather exercises from the previous pages then I'm pretty convinced that you'll have already achieved something great.

So applying the former exercises of drawing without looking at your paper is just as relevant in your attempts to discover the essence of movement. Again, since we are normally so result-led, it is easy to become disheartened – there will be many apparent failures. No work in the right direction goes unrewarded though; with persistence and dedication you will experience more moments of 'real' connection – it's worth the effort!

A couple of drawings that I did without looking at the page as I went. Drawing in ths way enables you to follow the movement more naturally with your eyes, and you might even be surprised when you do look down.

You will need

A PLACE WHERE YOU CAN OBSERVE
MOVEMENT
A SHARP 1B PENCIL
A SKETCH PAD, A3 OR SMALLER

Tip

REMEMBER, YOU ARE NOT TRYING TO MAKE GOOD DRAWINGS; RATHER YOU ARE TRAINING YOURSELF IN SHARPNESS AND ACCURACY OF OBSERVATION.

Two figures on a London street, drawn without looking at the paper., as they went about their daily business. The strength of pen line in this style of drawing is an immediate way of really capturing the movement. By Denisa Nenova.

MOVEMENT EXERCISE

As long as you need

Take yourself to any environment where you can observe movement. The list, of course, is endless: cafés, parks, train stations, wildlife parks, shopping centres, museums, airports, pets, your friends, performances, concerts ... When trying this exercise for the first time, you may find it less daunting to find movement that is relatively slow, for example, at a museum.

1. Complete the Sense Exercise (see page 23) in order to draw from silence and stillness.

2. When you begin drawing, keep your eyes and your attention riveted on the subject. You will be compelled to draw very fast – don't be scared by the speed.

3. Allow your pencil to effortlessly track the rhythm of the movement. Don't be frustrated that you didn't capture everything or that your subject moved too soon. Just keep drawing without looking down at your paper and become lost in your seeing.

4. Be totally absorbed in the activity, removing all thoughts or worries about the drawing – it can be surprisingly relaxing! Feel yourself become one with the movement. Continue to fill your paper or sketchpad with as many drawings and impressions as possible, go with the flow and stop when you feel that you have captured the moment.

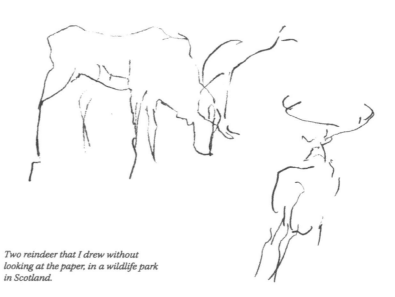

Two reindeer that I drew without looking at the paper, in a wildlife park in Scotland.

A CAPTIVATING PERFORMANCE

The following sequence of drawings are from a flamenco ballet performance in Valencia, Spain. As you can imagine, some flamenco is lightning-fast, so I was excited by the challenge. As it was, I ended up not being able to see my sketchbook at all, because the lighting was very low. In fact, the darkness was a big help since it removed any temptation to look down or be concerned about the outcome!

By drawing with such full attention on seeing for such an extended time, I was completely captivated by the whole experience. I have rarely tasted such a closeness with the performance. At times I hardly knew I was drawing.

It was great fun going to a café afterwards to view the sketchbook of 50 or so drawings that I'd created but never seen. I was faced with marks such as you see here. It's interesting to see figures starting to form but look beyond that for a moment. Notice how the quality of the lines reflect something of the passion, vibrancy and energy of the dance: a flicker here; a sweep there, the curl of a gesture. I was surprised and delighted to find that one drawing in the sequence had somehow magically captured the form and character and movement of one of the dancers.

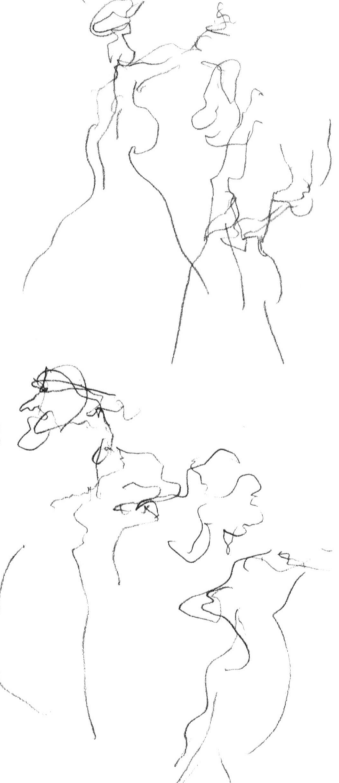

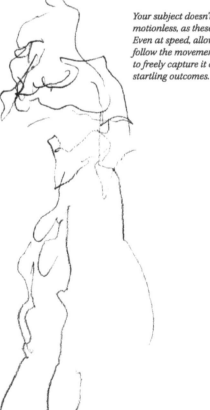

Your subject doesn't have to be motionless, as these drawings show. Even at speed, allowing your eye to follow the movement and your pencil to freely capture it on paper can have startling outcomes.

The more you practise and the more you allow this freedom, the easier and more natural it will become. It may at first seem daunting not to be able to look at your drawing as it is in progress, but you will soon adapt and may even find it liberating.

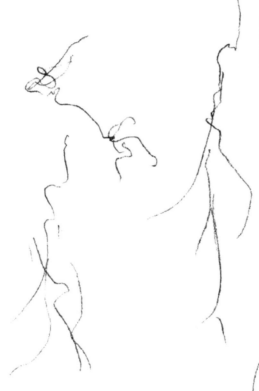

ASSESSING YOUR DRAWINGS

Take a look at the variety of marks and impressions that you have made. Don't be disappointed if you can't immediately identify people or shapes, their impression will be there in the expressive quality of your pencil marks. Look beyond the conventional to see the essence of the movement and you will soon identify the moments that you captured. Train your eyes to focus attention on the process and enjoy the possibility of achieving the impossible...

This last drawing has really captured the essence, form and character of the dancer – a pleasant surprise when I came to look at the paper, given the speed of movement!

MOVEMENT

WE CAN GET SOME IDEA OF HOW MOVEMENT MIGHT INFORM YOUR WORK BY HAVING A LOOK AT THE PAINTING OPPOSITE, ENTITLED 'NOW JUMP!'. THIS IMAGE FROM KENNETH GRAHAME'S *WIND IN THE WILLOWS* DEPICTS THE MOMENT OF TOAD'S LEAP FROM THE TRAIN DURING HIS GETAWAY FROM PRISON.

MOVEMENT IS INFLUENTIAL, NOT JUST IN THE WAY YOU MANIPULATE YOUR CHARACTERS, BUT ALSO IN THE WAY THAT THEY INTERACT WITH THE BACKGROUND. COMPOSITION, THE USE OF DIAGONALS AND LIGHTING IN THIS CASE, ALL CONTRIBUTE TO THE OVER-ALL EFFECT.

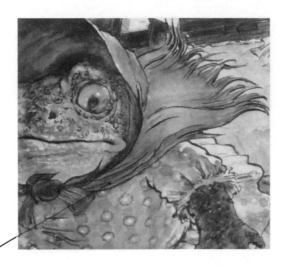

THE FOCUS OF THE PICTURE IS THE DRAMATIC MOTION OF THE FLYING TOAD, ACCENTUATED BY HIS BILLOWING SCARF.

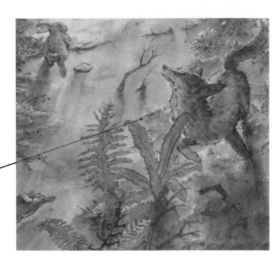

THIS MOVEMENT THOUGH IS EMPHASIZED BY THE POSITION AND POSES OF THE OTHER ANIMALS BENEATH WHO ARE WITNESSING THE ESCAPE. THE HIGH VIEWPOINT GIVES A FEELING OF THE SPACE BENEATH TOAD AND THE DANGER OF THIS ESCAPADE.

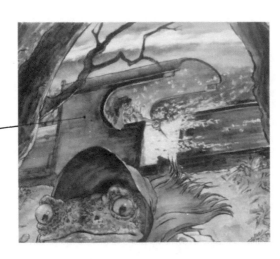

FURTHER EMPHASIS IS GIVEN BY THE CONTRASTING DIRECTION AND SPEED OF THE TRAIN AND BY THE LIGHT OF ITS FIRE, CASTING LONG AND DEEP DIAGONAL SHADOWS INTO THE FOREGROUND AND ECHOING TOAD'S JUMP.

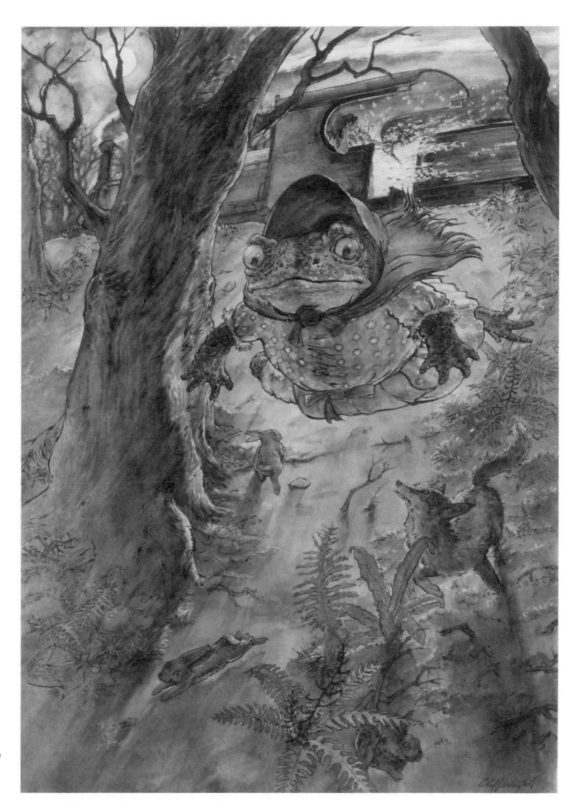

'Now jump!' – an image from Kenneth Grahame's Wind in the Willows, *depicting the moment of Toad's leap from the train during his getaway from prison.*

THE JOURNEY SO FAR

WELL DONE! IF YOU'VE WORKED THROUGH THE EXERCISES SO FAR YOU WILL HAVE DELVED DEEPLY INTO YOURSELF AND WILL HAVE A REAL SENSE OF HOW YOU SEE (OR DON'T SEE!) THE WORLD AROUND YOU. YOU MAY HAVE HAD GLIMPSES OF A PLACE BEYOND THE THINKING MIND WHERE DRAWING COMES AS EASILY AS BREATHING AND MASTERPIECES ARE MADE. IF THAT'S THE CASE YOU WILL HAVE EXPERIENCED SOME OF THE ESSENCE OF THE OBJECT OF YOUR ATTENTION AND THAT MAY HAVE FELT VERY FAMILIAR — LIKE SOMETHING YOU ALREADY KNOW, SOMETHING DEEP INSIDE YOURSELF. IF YOU'VE HAD EVEN THE SLIGHTEST TOUCH OF THIS YOU'LL BE HOOKED ON DRAWING FOR LIFE.

Of course, it may be equally true that none of this has happened and that you've struggled with all the exercises up to this point. Don't worry – you're not alone. In fact you may have an advantage. The curious thing about truly 'meeting the moment' in your drawings is that it can happen in an instant, with very little preparation. Some individuals on my workshops have experienced this and it is wonderful, because everyone recognizes it. The danger then arises in trying too hard to 'make' it happen again. The magic of drawing cannot be forced, only arrived at. The best you can do is set up the right conditions and then be prepared to work at it. So, if you feel that you have battled away and nothing has happened so far, don't be daunted – you have set up a great discipline and persistence is the key.

'The first snow that falls on the ground in wintertime does not immediately whiten the earth. Gradually the snowflakes cool the ground until it is cold enough to accept them without melting them. Whiteness then becomes visible as if suddenly, everywhere.' SWAMI KRIYANANDA, 'THE ESSENCE OF THE BHAGAVAD GITA'

PART TWO — TOWARDS A FINE TOUCH

You must stop that hand of yours, however painfully; make it understand that it is not to have its own way anymore, that it shall never more slip from one touch to another without orders; otherwise it is not you that are the master, but your fingers.' JOHN RUSKIN, 'THE ELEMENTS OF DRAWING'

IN THE PREVIOUS SECTION YOU SHOULD HAVE GAINED A CERTAIN SENSE OF FREEDOM TO ALLOW THE DRAWING TO HAPPEN, RATHER THAN 'TRYING' TO CREATE IT. AIMING FOR FREEDOM THOUGH CAN BE LIKE AIMING FOR THE FINAL RESULT — IT MAY SLOW YOU DOWN, SINCE IT CANNOT BE FORCED. WE CAN, HOWEVER, SET UP A JOURNEY OF PRACTICES WHICH WILL GIVE US THE BEST CHANCE OF MEETING THAT MAGICAL MOMENT. THUS, IN ANTIDOTE TO PART ONE, HERE WE'RE GOING TO EXPLORE COMPLETE CONTROL, IN THIS CASE OVER THE MOVEMENT OF YOUR HAND AND MASTERY OF YOUR DRAWING MATERIALS.

Remember the idea, introduced in Part One, that discipline leads to freedom? When you begin a drawing of an object, the process can start with seeing; the vision, continues through your heart, and its final manifestation on the page is carried out by your hand. What we need is to exercise control and fine-tune the movement of your hand, for a touch that can capture the infinitely varied nuances of the ways you see and your emotional response. How precisely and instantly does your hand follow the signals that you send it?

The following exercises, usually very simple to set up, will help remove the obstructions that may have developed between eye and hand. Please remember though, the message is still not about trying to create pretty works of art. For now, keep your attention on the journey of making your technique strong. The exercises demand your full attention. Relax, without thinking, tune-out totally from whatever you were doing and give yourself fully to the task presented so that your attention is focused not forced. Remember also that half an hour of true, careful and considered attention is far more worthwhile than a whole day spent in casual, inattentive and tired toil. Practise precisely and regularly and you *will* start to see things very differently but beware ... it can become addictive!

Tangleweed Troll

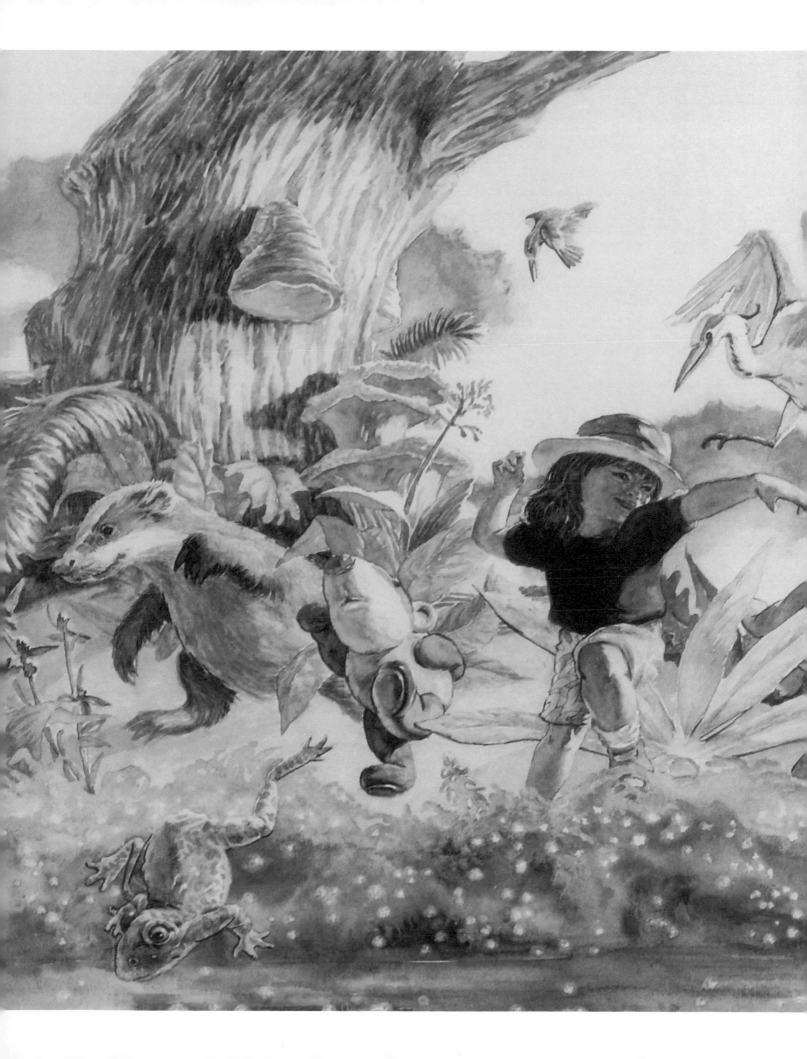

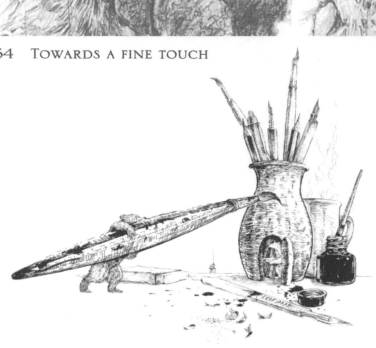

TOOLS FOR THE JOB

FOR THE EXERCISES IN PART ONE I RECOMMENDED A PENCIL, KEEPING THE FOCUS ON YOUR SENSES RATHER THAN THE SUBTLETIES OF THE DRAWING. BUT TO FINE-TUNE YOUR TOUCH IT IS WORTH EXPLORING THE ARRAY OF ARTIST'S MATERIALS THAT ARE AVAILABLE. BEYOND THE TWO BASICS OF PENCIL AND BALLPOINT PEN THAT I USE, IT'S IMPORTANT TO EXPERIMENT WITH ALL KINDS OF DRAWING MEDIA. USE AS MANY AS YOU CAN AND FIND YOUR FAVOURITES. ALSO, TRY TO MASTER THOSE THAT DON'T IMMEDIATELY ATTRACT YOU. YOU MIGHT LIKE TO CHALLENGE YOURSELF BY ATTEMPTING FINE AND SUBTLE LINES WITH A MARKER PEN, FOR EXAMPLE. TRY ANYTHING THAT WILL ENCOURAGE A FINE AND PRECISE TOUCH, AND HAVE FUN WITH IT!

Tip

USE A SHARP KNIFE, OR A SCALPEL FOR PRECISION, TO SHARPEN YOUR PENCILS — THEY WILL GIVE A MUCH FINER POINT THAN A PENCIL SHARPENER. NOT ONLY WILL THIS ENCOURAGE A LIGHT TOUCH, BUT THE PENCIL WILL LAST A LOT LONGER. WHEN SHARPENING, WORK DOWN TOWARDS THE POINT, 'WHITTLING' AS YOU CONSTANTLY ROTATE THE PENCIL (SEE PAGES 56—57).

PENCIL

It's probably true to say that there is nothing better than good old pencil and paper. I use B or 2B most of the time because they will take a fine point without wearing down too soon and give you a good range of tones. Try graphite pencils too, from 3B and upwards, since they are very smooth and expressive.

BALLPOINT PEN

Make sure it is of good quality, preferably in a metal casing with some weight. Practising with the ballpoint is good for several reasons. Firstly, it will work for ages without running out or need sharpening; so you can focus fully on the drawing. Additionally, it is harder to achieve finesse with such a relatively mechanical point. Thus, when you return to your pencil your touch is likely to be all the finer.

PAPER

Any sketchpad or sketch paper is fine for most of the exercises included here. To experience a finer touch buy the smoothest paper, such as good quality cartridge.

DRAWING AND MAPPING PENS

Drawing pens, with a nib that you can refill with ink, are good for producing lines of varying width just by altering the pressure on the page. Mapping pens are good for very fine lines. Both will help you achieve more depth and expression in your drawings. Most of the watercolours in this book are drawn with a drawing pen. When using a drawing or mapping pen it is critical that you angle the surface that you are working on. If you work flat, the angle of the pen is too high and will 'drip'. Angle your board to around 30 degrees, so that the pen is almost flat – in this way the ink will flow smoothly.

ERASERS

Do you need an eraser? There are no hard and fast rules in drawing. For all but two of the exercises included here, you won't need one. When you're learning you risk relying on the idea that you can rub out, diverting your attention from 'real' seeing. For practice, try to avoid using an eraser. Later on I would recommend putty rubbers; they are the most precise and will erase soft pencil without smudging.

SOFT MEDIA

Charcoal, chalk or pastel are different again since you can produce such a wide variety of marks, lending themselves to quick, expressive drawings and suitable for use on more textured paper.

INK

For the exercises included here, any black drawing ink will suffice. If you want to use a wash over the top of the ink and don't want the drawing to smudge, then use a permanent ink.

BRUSHES

A fine brush is a great and subtle drawing instrument. It is worth buying a range of good-quality brushes, depending on the size of drawing you want to create. Incredibly expressive lines can be created with the extra fine touch needed to manipulate a brush. Try before you buy if possible and get a sense of how well the brush holds and distributes liquid.

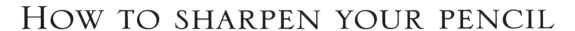

HOW TO SHARPEN YOUR PENCIL

A SHARP KNIFE WILL GIVE A MUCH FINER POINT THAN A PENCIL SHARPENER EVER CAN. NOT ONLY WILL THIS ENCOURAGE A LIGHT TOUCH, BUT THE PENCIL WILL LAST A LOT LONGER. SHARPENING WITH A KNIFE IS AN ART IN ITSELF AND REQUIRES MUCH PRACTICE — I HAVE FOUND THAT THE MORE RELAXED I AM, THE FINER THE POINT I CAN ACHIEVE AND IN THE QUICKEST TIME. DO A VERSION OF THE SENSE EXERCISE (SEE PAGE 23) TO HELP YOU TO RELAX BEFORE YOU START AND, AS WITH YOUR DRAWINGS, GIVE IT YOUR FULL ATTENTION.

BEGIN ON THE COLOURED PART OF THE PENCIL, ROTATING AND CUTTING UNTIL YOU HAVE A GOOD LENGTH OF EXPOSED WOOD

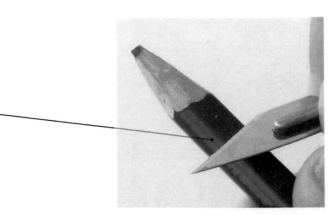

CONTINUE WHITTLING DOWN TOWARDS THE END OF THE EXPOSED WOOD

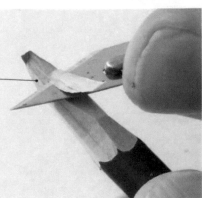

GRADUALLY EASE OFF THE PRESSURE AS YOU APPROACH THE LEAD, SHAVING FINELY AT THIS STAGE

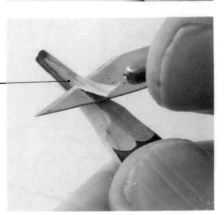

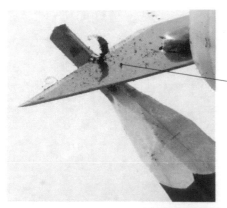

ONCE YOU HAVE A LENGTH OF GRAPHITE EXPOSED, BEGIN WHITTLING THAT, AGAIN CONSTANTLY ROTATING THE PENCIL AND USING A MUCH LIGHTER TOUCH TOWARDS THE POINT

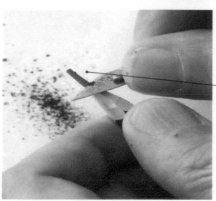

NEARLY THERE! TO CONTINUE TO REFINE THE POINT USE A VERY DELICATE, FEATHER-LIGHT TOUCH

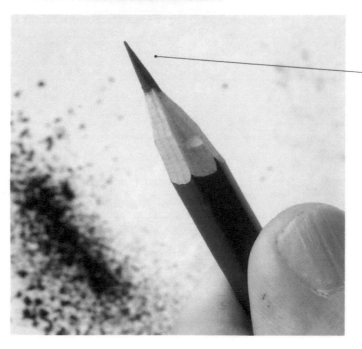

AFTER CAREFUL AND GENTLE WHITTLING, YOUR PENCIL NOW HAS A FINE, PRECISION POINT AND WILL LAST MUCH LONGER

Tip — FOR A REAL CHALLENGE, NOTE THAT YOUR PENCIL HAS SIX SIDES. YOU COULD TRY COMBINING ALL OF THE ABOVE INSTRUCTIONS IN EVERY SINGLE STROKE, AIMING TO HAVE YOUR PENCIL PIN-SHARP IN JUST SIX STROKES. YOU MUST PAY ABSOLUTE ATTENTION BUT GIVE IT A GO! THE MOST I HAVE MANAGED IS TEN STROKES.

THE FULL RANGE OF A PENCIL

OUR TEMPTATION WHEN DRAWING IS TO PRESS TOO HARD, TOO SOON. ANY SUBTLETY WE MIGHT HAVE HAD ACCESS TO CAN BE LOST IN THE FIRST FEW MOMENTS. TAKE A LOOK AT THE SINGLE LINE DRAWN ON THIS PAGE. VERY SIMPLY, I PRESSED AS HARD AS I COULD AT THE OUTSET AND FINISHED UP USING NO PRESSURE AT ALL, WITH JUST THE WEIGHT OF THE PENCIL MAKING THE MARK.

It is my experience that most of us only draw within a very narrow band of this range, right up towards the darker end. The pencil has a far greater range than that, so why not use it all? Training yourself to under-do as opposed to over-doing will also encourage your eye to perceive with more precision and subtlety. The following exercises will attempt to demonstrate the variety of marks that can be achieved with the pencil and other media and encourage an increasingly fine touch.

MOST OF US DRAW WITHIN THE TOP THIRD OF THE LINE

Keep your touch light – you can always darken your drawings when you are happy with them.

THE LINE FADES TO VIRTUALLY NOTHING HERE

A LINE DRAWN WITH 1B PENCIL
Begin by pressing as hard as possible (without breaking the lead!) then gradually release the pressure, until there is no pressure at all. We mostly use the pencil only at the top third of this line where the pressure is hard and the hand is tense. It's worth remembering that marks can be seen even when there is no pressure applied.

Tip THE PENCIL SHOULD BE HELD FIRMLY BUT WITHOUT TENSION TO ACHIEVE FLUIDITY AND SUBTLETY.

REVERIE
This was completed with a 2B pencil demonstrating the variety and contrast that can be achieved by using the full range of marks. The soft quality of the face, hands and legs was created by building up the shading with a feather-light touch. Compare this with the texture of the tree; it was rendered through a combination of very hard and soft lines, keeping the pencil pin-sharp at all times. Note the lightest, barely seen touches of fine raindrops and subtle grading of the sky above the mountain against the darkness of the girl's hair. The highlight on the neck is the only area of the face and neck left as white paper.

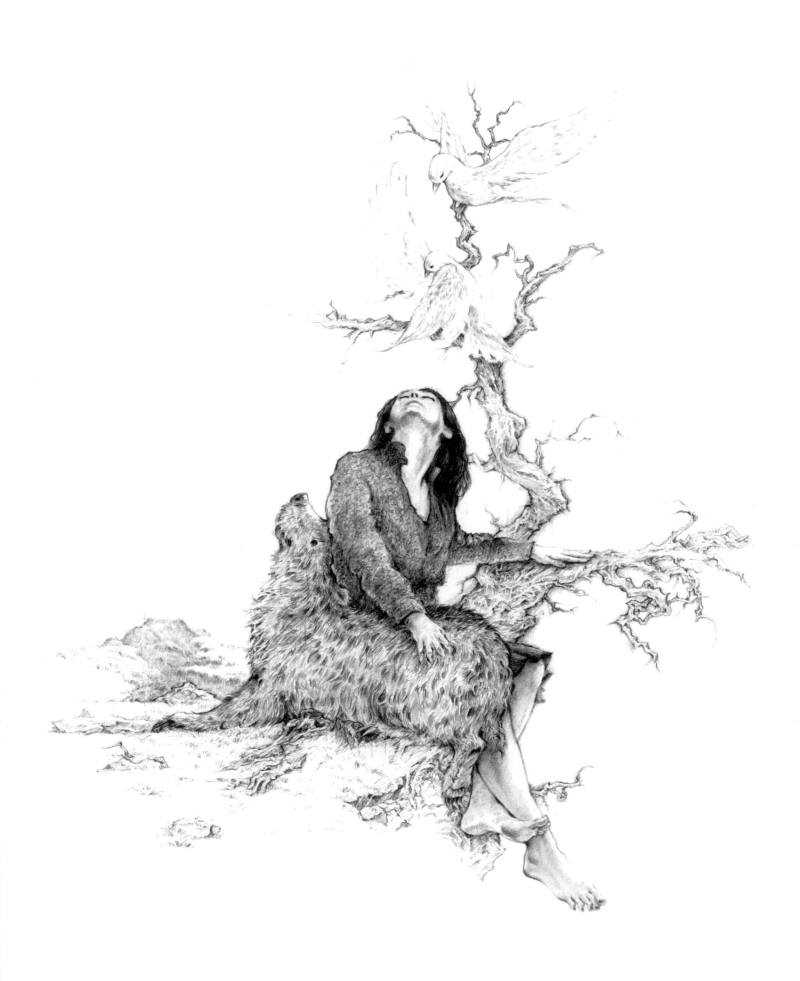

FREEFORM DRAWING

TO DEVELOP A FINE TOUCH, YOUR HAND AND MIND WILL NEED TO BE FREE OF TENSION. FREEFORM DRAWING, WHERE YOU LET YOUR PEN OR PENCIL MOVE ACROSS THE PAPER IN RESPONSE TO A DIFFERENT SENSORY STIMULATION, SUCH AS MUSIC, IS A PERFECT WAY OF LETTING GO AND ALLOWING YOUR HEART TO GUIDE YOU. PRACTISE IT AS OFTEN AS YOU LIKE TO LOSE YOUR MIND AND COME TO YOUR SENSES. USE IT AS AN OPPORTUNITY TO EXPLORE YOURSELF, YOUR RESPONSES AND THE REAL NATURE OF YOUR DRAWING IMPLEMENTS.

You will need

- A QUIET PLACE FREE FROM DISTRACTIONS
- AN UPRIGHT DINING CHAIR
- SOME MUSIC
- AN A3, OR BETTER STILL, A2 SHEET OF PAPER
- A STICK OF GRAPHITE OR GRAPHITE PENCIL
- A SHARP 1B PENCIL

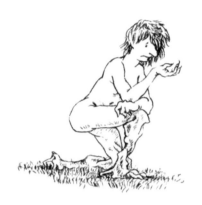

FREEFORM DRAWING EXERCISE
5 minutes

This exercise will allow you to free both your mind and your drawing. It can be very helpful to play a piece of music to take you through this – find a piece with contrast or that builds in atmosphere, such as 'Glósóli' from the album 'Takk' by Sigur Rós.

1 Complete the Sense Exercise (see page 23) to help you focus and be fully present.

2 Pick up the two drawing tools, one in each hand. Feel the point where the pencil touches the paper – be as sensitive as you can. Allow yourself to feel the nature of the relationship between the drawing materials and the paper – is it light, heavy, scratchy, soft?

3 Play your music. With eyes closed and holding your drawing tools lightly, start making marks on the paper by rolling and moving them in your hands. Move in response to your intuitive impulse and release any element of 'doing'. Explore a journey across your sheet, using the nature of these four guiding elements:

The drawing tool. Fully explore its nature – every side, every angle, its tip, its weight, its body and your relationship to it. How does it feel to drag it, push it, roll it, to let it be loose, to grip it, to roll it around one point?

The paper. Feel the touch of your paper. Smell the scent of it. Explore its receptiveness to mark-making. Does it ask to be scribbled over, swept across, caressed, scratched upon?

The music. Reflect the nature of the music, be fully absorbed and make every mark authentic. Respond to its rises and falls; its movement and patterns; its passions and depths; its highs and its lows.

Yourself. Move your body, roll your wrists, arms and shoulders, responding to your intuition. Allow the marks you make to arise from core impulses; to ripple along your arms, through your hands and on to the page.

4 Finish your drawing when the music ends and open your eyes. Take in the image and ask yourself how it speaks to you. What is the nature of the marks you've created? For example, are they light, free or heavy? Does the image reflect how you normally respond to the world?

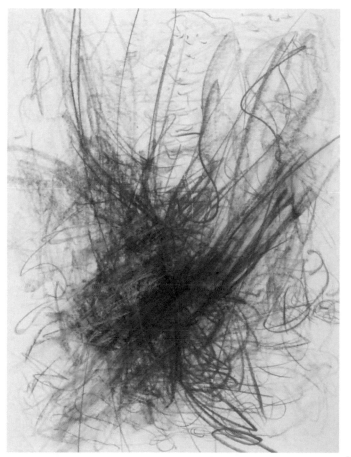

FREEFORM DRAWING EXERCISE — CLIFF WRIGHT

These two examples couldn't be more different but it is interesting that they are a response to the same piece of music suggested opposite. This one displays a huge range of marks from the very faint to the extremely intense and passionate dark (this is some of my favourite music!). There is a sense of something building towards a crescendo. This intensity of climax has arrived from a quiet space though, and some of that quietness can still be seen underneath the heavy ending. In the build-up there is a pattern of horizontal flicks running down the page, reflecting the slow but regular pace of the music. I like the faint lines that have been scratched back into the dark which probably reflects my need to find subtleties.

FREEFORM DRAWING EXERCISE — SAMIRA HARRIS

This second example is very coherent, also reflecting the piece of music. It seems as though Samira has used more of the movement of her hands as opposed to my drawing, which is more about the materials. The range of marks is very varied but also suggests a uniformity or a boundary – there is great control here, in amongst the apparent freedom. The marks are very expressive and free, reflecting some of Samira's character, but they are comfortable within the space, unlike mine which seem to be flying off the page. There is again the suggestion of something building and it's interesting that our most intense lines occur at the same place on both sheets, perhaps echoing the fact that we drew them at the same time.

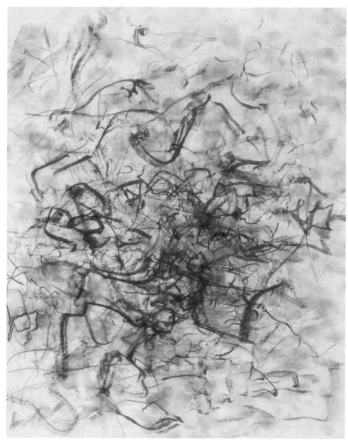

Within the apparent limitations of simple mark-making we have a priceless chance of seeing who we think we are; then transcending that boundary to fly in all kinds of new, unfettered universes

EXPLORING A LINE

NOW THAT YOU'VE EXPERIENCED THE RELEASE OF FREEFORM DRAWING, YOU WILL HAVE NOTICED THE INCREDIBLE RANGE OF MARKS THAT YOU CAN PRODUCE. WE'LL NOW RETURN TO A LITTLE MORE CONTROL BY INTENTIONALLY MAKING MARKS THAT ARE VARIED: BEING BOTH EXPRESSIVE AND PRECISE.

This exercise requires you to vary the pressure, direction and speed of the line, and to use both hands. You will notice a difference in the type of marks compared to your freeform drawing; both of these experiments in mark-making though are invaluable in your progression towards a finer touch.

For a bit of fun, but of immense benefit, try the exercise with both hands simultaneously. In other words use two sheets of paper side by side and complete the sequence of straight and curved lines, left hand on one, right on the other – drawing with both at the same time. You might allow the two hands to 'copy' each other or intentionally make them go in different directions. Pay attention to how it feels and enjoy the experience.

You will need

A QUIET PLACE FREE FROM DISTRACTIONS

AN UPRIGHT DINING CHAIR

A SHARP 1B PENCIL

AN A3 SHEET OF PAPER

EXPLORING A LINE EXERCISE

15 minutes

Make sure your hands are loose by giving them a shake if necessary and keep your grip relaxed throughout this exercise.

1 Complete the Sense Exercise (see page 23) and be fully present.

2 With your dominant drawing hand, draw straight lines all over the page. Use your full attention to make sure these lines are as straight as you can possibly achieve. Keep your pencil on the paper *at all times*.

3 *Every* time you change direction remember to alter three things: **1** the pressure that you exert; **2** the speed that you draw the line; **3** the length of the line. Enjoy the challenge of trying to make your lines look like they have been drawn with a ruler. Keep your touch light and simply notice how some directions, or speeds or pressures are easier than others.

4 After a few minutes try holding your pencil at its top end and continue these straight lines. If you haven't done so already, remove your hand, wrist and elbow from touching the table – but keep your shoulder relaxed.

5 Now, with only the point of the pencil in contact with the paper, change hands to your non-dominant hand. At first this might seem awkward, but persist. Notice how different it feels. Bring all of your attention to the point where the pencil meets the paper.

6 Continuing with your 'other' hand, move on to the next stage and change the straight lines into curves, circles or spirals. Remember to keep altering the shapes and avoid trying to 'make' patterns. Allow your hand to be loose and free. After a few minutes, transfer your grip back to the 'normal' end of the pencil and continue the curve – just allowing the shapes to form themselves.

7 Finally, swap back to your dominant hand and continue these curved lines, keeping your touch soft and hand relaxed. Finish by returning to a few straight lines as before, noticing any differences that may have occurred. Is it now easier to complete the lines? Do you feel more relaxed?

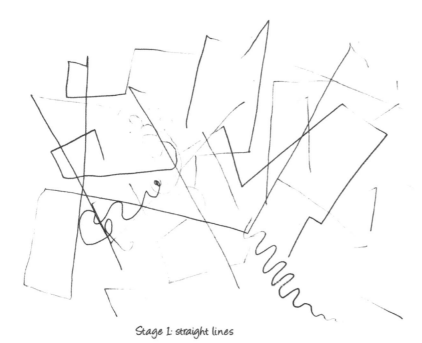

Stage 1: straight lines

Exercising control and fine-tuning the movement of your hand will open the floodgates to all kinds of new-found subtlety within your drawings

Stage 2: curved lines

EXPLORING A LINE EXERCISE — DENICA NENOVA

The abstract nature of this result is reminiscent of Kandinsky or Picasso. However, looking beyond the immediate picture, you can identify the huge variety of marks that are possible – thick lines, thin lines, hard and soft, straight and curved. This impressive variety is at your fingertips, waiting to be released.

A FINE TOUCH WITH DIFFERENT MEDIA

USING DIFFERENT MEDIA WILL ENCOURAGE YOU TO SEE YOUR SUBJECT AND 'FEEL' IT DIFFERENTLY. CHOOSE A RANGE OF MEDIA, SELECT YOUR OWN OBJECT TO DRAW, THEN DRAW IT WITH EACH DIFFERENT IMPLEMENT. ALLOW THE MEDIA TO DICTATE YOUR RESPONSE — DON'T BE TOO PRECISE AND ENJOY THE DIFFERENCES. PREPARE YOURSELF CAREFULLY BY TAKING YOURSELF THROUGH THE SENSE EXERCISE FIRST (SEE PAGE 23). ALLOW YOURSELF TO FIND THE FULL RANGE OF WHATEVER YOU CHOOSE TO DRAW WITH AND FIND NEW WAYS TO RENDER YOUR OBJECT. CONTINUE TO FOCUS ON EXACTLY WHAT YOU SEE, NOT WHAT YOU THINK IS THERE.

The following examples show how differently the same subject can be rendered in different media, the qualities of each guiding the overall feel and essence of the image. It's easy to see how you can influence the impact and meaning of your drawings through your own choices and response to your subject.

CHARCOAL — 20 MINUTES
A delicate subject calls for a delicate touch and this feather is rendered in soft sweeps of charcoal, following the downy nature of the subject. Charcoal lends itself to soft lines and gently smudged tones, but with the option of heavier marks to add depth when required.

MARKER — 5 MINUTES
Despite the harder edges and solid lines, the feather still retains a delicate presence on the paper but the speed at which it was drawn has given it an immediacy that brings it to life through quick strokes and dashes. With such a strong line you must take care not to over-do the marks.

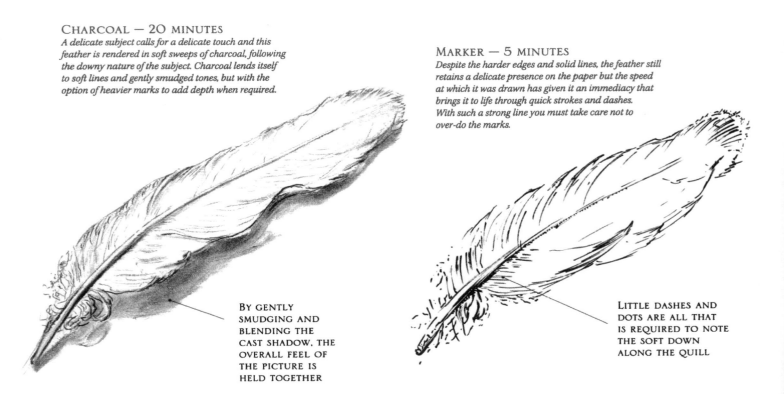

BY GENTLY SMUDGING AND BLENDING THE CAST SHADOW, THE OVERALL FEEL OF THE PICTURE IS HELD TOGETHER

LITTLE DASHES AND DOTS ARE ALL THAT IS REQUIRED TO NOTE THE SOFT DOWN ALONG THE QUILL

PENCIL — 20 MINUTES

This study combines hard and soft edges, shading and detailing to great effect and illustrates how a simple medium can be used with precision and a delicate touch.

THE CRISP FORE EDGE OF THE LEAF IS RENDERED BY USING THE TIP OF THE PENCIL WITH FIRM PRESSURE, IN CONTRAST TO THE SOFTER IMPRESSION OF THE STALK WHERE IT RECEDES INTO THE BACKGROUND

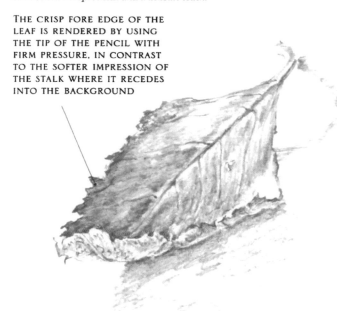

MARKER — 10 MINUTES

In contrast to the pencil study, this drawing took half the time to complete but is equally as successful in conveying the nature of the object. Fluid strokes quickly convey the form and the uniform line gives the drawing an immediate impact.

BY VARYING THE DENSITY OF THE SHADING YOU CAN SWIFTLY GIVE A SENSE OF TONE

LOOSE STROKES OF THE PEN FOLLOW THE SHAPE OF THE CAST SHADOW, WITH CROSS-HATCHING GIVING DEPTH TO THE DEEP AREAS OF SHADE

PENCIL — 15 MINUTES.

Study of a fox. This animal was found by the side of the road, sadly having been hit by a car – a rare opportunity for a quick study of an animal normally so elusive. Pencil is the ideal medium for rendering the fine quality of fur. Short, quick strokes with a variation of pressure give the three-dimensional, light and soft effect. A furry creature is a good subject for study since the outer appearance conceals a different inner form.

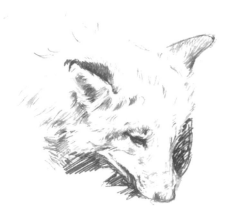

PEN — 5 MINUTES.

After completing the pencil study this quick pen sketch was a lot easier. Concentrating the detail and weight of marks in the head area with simple cross-hatching, the outline of the body becomes a fast combination of simplified short strokes to indicate the fur and line to complete the shape. It's a very effective means of giving the maximum information, if time is short.

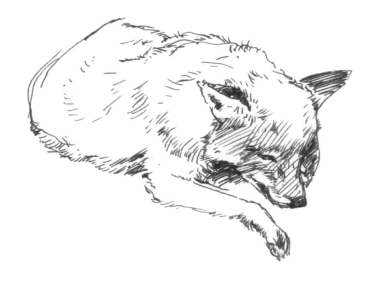

CONTROLLING YOUR TOUCH

AT SOME POINT YOU ARE GOING TO WANT TO GO FURTHER THAN A LINE DRAWING CAN AND TO EXPRESS FORM WITH SHADING. THERE ARE ALL KINDS OF WAYS TO ACHIEVE ACCURATE SHADING BUT ALL THE FORMER ESSENTIALS STILL APPLY. FIRST AND FOREMOST, LET YOUR VISION BE YOUR GUIDING LIGHT AND FOR NOW COPY EXACTLY WHAT YOU SEE. BUILD AN ACCURATE KNOWLEDGE OF HOW LIGHT AND SHADE ACTUALLY WORK ON DIFFERENT OBJECTS. NEXT, KEEP YOUR TOUCH SOFT, FOLLOWING THE ADVICE OF LEONARDO DA VINCI.

Take care that the shadows and lights be united, or lost in each other without any hard strokes or lines; as smoke loses itself in air, so are your lights and shadows to pass from one to the other, without any apparent separation.' LEONARDO DA VINCI (1452–1519)

To give you a sense of the touch we are aiming for, try the following exercises before moving on to attempting to convey form through light and shade. These exercises will give you a sense of how to achieve careful shading and precise lines, which in turn will be invaluable when you come to render the subtle changes in tone required to convey light and shade.

You will need

- A QUIET PLACE FREE FROM DISTRACTIONS
- AN UPRIGHT DINING CHAIR
- AN A4 SHEET OF PAPER
- A BALLPOINT PEN

This square took me 3 minutes to shade in. The lines of hatching and cross-hatching are loose and visible.

My second square took 7 minutes to complete, and by comparison the ink appears more solid and the shading denser.

SHADING EXERCISE

10 minutes

This simple exercise is a quick demonstration of how you can control the density and impression of your marks.

1. Complete the Sense Exercise (see page 23) and be fully relaxed.

2. Draw a 4-cm (1¹⁄₂-in) square. Now, with your ballpoint pen, start to shade the square in by drawing lines all across it in one direction then cross-hatching in the opposite direction. Use four directions; the two diagonals plus the horizontal and vertical. Finish when you have 'blacked out' the space.

3. Now draw a second square to the same dimensions and complete the same exercise, this time pressing as *lightly* as you can with each succeeding layer. This square will take longer to 'black out' but you should find that your shading is much more even than the first attempt.

Tip

HATCHING AND CROSS-HATCHING ARE THE MOST COMMON MARKS THAT YOU CAN MAKE TO RENDER LIGHT AND SHADE. HATCHING IS THE CREATION OF SHORT, FAST STROKES IN ONE DIRECTION. CROSS-HATCHING IS TO OVERLAP THOSE SHORT STROKES USING SEVERAL OPPOSING DIRECTIONS.

You will need

AN UPRIGHT DINING CHAIR

AN A4 SHEET OF PAPER

A SHARP 1B PENCIL

AN ERASER

A DRAWING PEN

PRECISION EXERCISE

10 minutes or more

Copying is a useful discipline to encourage fine control over your hand.

1 Complete the Sense Exercise on page 23.

2 Take a look at the drawing on the right. Make a direct copy of it, avoiding the temptation to trace. Erase where necessary until the drawing is completely accurate. Don't be satisfied until it looks exactly the same.

3 Now go over your pencil lines with your drawing pen – aiming to keep the line width the same all over. In other words don't vary the pressure. Take some time over this and use your full attention – precision comes with patience!

CAPTURING LIGHT AND SHADE

NATURE'S PLAY OF LIGHT AND SHADE IS DECEPTIVELY SIMPLE, FOR IT IS INFINITELY VARIED AND WILL KEEP YOU GUESSING FOR A LIFETIME. THERE IS A NEED TO OBSERVE HOW LIGHT STRIKES AN OBJECT BUT ALSO TO SEE HOW SHADE RELATES TO ITS SURROUNDINGS. AS LIGHT IS REFLECTED FROM OTHER SURFACES, IT BOUNCES BACK TO ALTER THE SHADE OF YOUR ORIGINAL OBJECT.

The easiest way to see this is to start with something simple – if you can shade something simple perfectly, it will give you great confidence to take on more complex subjects. I have recommended a pear for the Seeing Light exercise; it has a simple shape and a matt surface that will help to identify changes in light and shade. The Changing Light Exercise will also help you to see how tones change in different conditions.

Use the subtle and different qualities of your subject to guide how you make your marks when shading. As always, your fineness of seeing should dictate the movement of your hand. It can help to work back from light to dark, so firstly identify where the highlight is and where the very darkest point is to be found. Give yourself a few minutes to see this before you start drawing. Use loose, light strokes keeping the edges soft and build up darker tones evenly and slowly, remembering that the tendency is to over-do. Allow the quality, direction and strength of your lines to explain the form, rather than opposing it.

THE DENSITY OF THE CROSS-HATCHED LINES BUILDS HERE WHERE THE PEAR'S FORM FALLS INTO DEEPER SHADOW

GENTLE STROKES OF THE PENCIL TRACE THE EDGES OF THE HIGHLIGHTS

You will need

FOR SEEING LIGHT EXERCISE
A QUIET PLACE FREE FROM DISTRACTIONS
AN UPRIGHT DINING CHAIR
AN A4 SHEET OF PAPER
A SHARP 1B PENCIL
A PEAR

FOR CHANGING LIGHT EXERCISE:
A QUIET PLACE OUTSIDE FREE FROM
 DISTRACTIONS
AN A4 SHEET OF WHITE PAPER
A SHARP 1B PENCIL
A PEBBLE, SMOOTH NOT SHINY, ROUGHLY
 7.5CM (3IN) IN DIAMETER

SEEING LIGHT EXERCISE — DENICA NENOVA
You may be surprised at the lightness of the pencil marks on this drawing of a pear, but they accurately convey the differing shades across the pear's surface. Cross-hatched lines build gently to give form and only in the darkest shadows, such as beneath the stalk, does a more solid mark convey the change in tone.

SEEING LIGHT EXERCISE

20–30 minutes

Use a pear for this exercise since it is evenly coloured and not shiny – which would make the light harder to see. Set it down on a sheet of white paper and direct a light source on to one side from slightly above.

1 Complete the Sense Exercise on page 23 and on opening your eyes, study the pear, spending a few minutes noticing the light and shade. Don't be satisfied with thinking that this part is darker than that – find where the darkest black is and the brightest white. Look in great detail. Notice that the white surface on which the pear is standing reflects light back into the shadow areas.

2 Begin drawing by trying to render exactly what you see – not what you think is there. Keep your touch delicate and fairly fast and build up the darks slowly. Use your full attention, spending around 20–30 minutes to complete the drawing.

3 Concentrate on blending the tones softly without any hard edges. Remember, this is a practice in looking and precision of touch. If you are not happy with your first attempt, learn from it and try again with a lighter touch still.

4 At first you may not find it easy to isolate the darkest of the dark tones or the lightest of the light. Invest all of your passion in looking. Try half-closing your eyes, which will eliminate detail on the surface of the pear and simplify the tones.

CHANGING LIGHT EXERCISE

10 minutes for each drawing

This exercise using natural light will give you a great sense of the subtleties of changing light.

1 Complete the Sense Exercise (see page 23).

2 Take your pebble outside and place it on a sheet of white paper out of direct sunlight. Do three drawings, each of them taking around 10 minutes. Complete the first right on sunset; the second 20 minutes after and the third 40 minutes after sunset.

Tip

IF YOU HOLD A SHEET OF WHITE PAPER AGAINST THE DARK SIDE OF YOUR PEAR YOU WILL REFLECT EVEN MORE LIGHT BACK INTO THE SHADOWS. IF YOU WERE TO USE RED PAPER THEN RED LIGHT WOULD REFLECT — NOTICE HOW DIFFERENT THE QUALITY OF REFLECTED LIGHT IS TO DIRECT LIGHT. MOVE THE PAPER AROUND AND SEE HOW IT AFFECTS THE SHADE ON THE PEAR.

SUNSET
Bright highlights of white paper have been left to indicate the top of the pebble where it catches the fading sunlight.

20 MINUTES AFTER SUNSET
As the light fades the tones become more uniform across the surface and the stone appears 'flatter'.

40 MINUTES AFTER SUNSET
The underside of the pebble is in darker shadow, indicated with blended and smudged tones, and its outline is more noticeable and defined.

OBSERVING LIGHT ON HANDS

THE PLAY OF LIGHT CAN BE INCREDIBLY COMPLEX AND DIFFICULT TO SEE AT FIRST. BUT IT IS SOMETHING THAT SURROUNDS US IN EVERY OBJECT OF OUR VISION AND IS AN IMPORTANT ELEMENT TO RENDER WITH FEELING AND UNDERSTANDING WHEN DRAWING. TO HELP YOU TO APPRECIATE THE RELATIONSHIPS BETWEEN LIGHT AND SHADE, LOOK AT YOUR HAND LIT BY LIGHT. OBSERVE HOW THE LIGHT CREATES SHADOWS, WHICH IN TURN ABSORB REFLECTED LIGHT FROM OTHER OBJECTS AROUND IT, NEAR AND FAR. PRACTISE OBSERVING IT ON ANYTHING AND EVERYTHING YOU COME ACROSS.

Your hands are a series of shapes and forms reflecting light with all kinds of subtlety. They are also always available. Notice the light on your hands – where is the source? Can you see the light bouncing back from other surfaces into the shadow areas? Place your hands against different objects and see how they affect the reflected light. Hands are often seen as a scary subject for many artists. Since they are so infinitely expressive and can invoke such varied moods, it is worth spending some time perfecting your fine drawing technique on them.

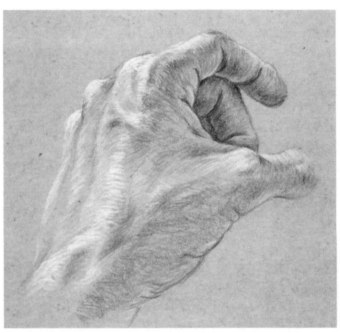

You will need

A QUIET PLACE FREE FROM DISTRACTIONS
AN UPRIGHT DINING CHAIR
AN A4 SHEET OF WHITE PAPER
A SHARP 1B PENCIL

Begin by making a few quick drawings using your vision only as you practised on page 26. Drawing without looking at the paper will force you to really see, and may deliver some of the essence of your shapes. The more detailed studies will be easier to focus on and thus benefit from such close initial observation.

RENDERING THE PLAY OF LIGHT EXERCISE

As long as you need

This exercise will help you to focus on identifying the relationships between light and shade and give you a chance to practise your skills in using a light, fine touch to express what you see.

1 Complete the Sense Exercise on page 23.

2 To start with, only draw one finger or thumb – make the task more manageable. Try to see as accurately and precisely as you can using your full attention. Begin by doing a few drawings using your vision only, as you practised with the feather exercises on pages 26–31. Don't worry about producing an accurate drawing.

3 Try different angles. Progress by making some studies of your hands in various lighting conditions. Try to render exactly what you see.

4 Now work on relating two fingers next to each other. Then progress to three, building yourself up to a final drawing of the whole hand.

TWO FINGERS
The relationship between two fingers can be shown by carefully observing the subtle changes of tone. Here the darker tones occur where the edge of the thumb overlays the finger, repeated in the creases on the palm. A soft line of brighter highlight follows the form along the top of the finger where the light falls.

THUMB
By isolating a single digit you can focus on relating it to the light sources, reflections and shadows that surround it. Note how the shape of the shadow follows the curve of the turned thumb, indicated by denser shading. The highlights on the top of the nail and skin indicate the direction of the light source.

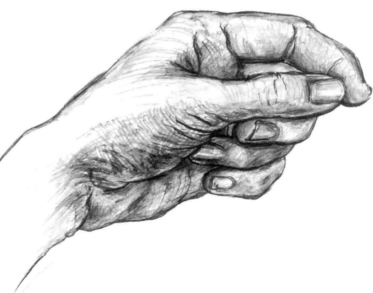

WHOLE HAND
Look carefully at the spaces between the fingers as these help to define their shapes. Dense shading hints at the form and depth, giving the hand a sense of three dimensions. Gentle, curving pencil strokes are all that is necessary along the top of the hand to give it form.

OBSERVING LIGHT SOURCES

TAKE A LOOK AT THE PAINTING OPPOSITE OF 'HARRY POTTER AND THE QUIDDITCH MATCH'. ESSENTIALLY, THERE ARE THREE LIGHT SOURCES. THE LIGHTNING IS PREDOMINANT BUT THE OBJECT OF HARRY'S ATTENTION, THE 'GOLDEN SNITCH' ALSO THROWS OFF A LOCALIZED GLOW. THE THIRD SOURCE IS THE YELLOW LIGHT NEXT TO THE CASTLE UNDERNEATH THE SMALLER FIGURE. PAY CLOSE ATTENTION TO THE MAIN FIGURE NOW AND NOTICE HOW HIS FORM RESPONDS TO THE PLAY OF LIGHT.

THE STARK BRIGHTNESS OF LIGHTNING ILLUMINATES THE RIGHT-HAND SIDE OF THE FACE. BUT THE LIGHT IS SO BRIGHT IT REFLECTS MOSTLY RED FROM THE CLOAK, BACK INTO WHAT WOULD OTHERWISE BE DEEP SHADOW ON THE LEFT-HAND SIDE OF THE FACE.

LIT STRONGLY BY LIGHTNING FROM THE RIGHT AGAIN, THE SHADOW IN THE PALM OF THE HAND IS GLOWING WITH YELLOW LIGHT CAST FROM CLOSE PROXIMITY WITH THE GOLDEN SNITCH, ITSELF LIT BRIGHTLY BY THE LIGHTNING.

THE DARK SIDE OF THE THIGH SHOWS ITS ROUNDED FORM WITH REFLECTED ORANGE AND YELLOW LIGHT FROM THE CASTLE AND YELLOW GLOW BENEATH.

Right: Harry Potter and the Quidditch Match, inspired by the book Harry Potter and the Prisoner of Azkaban, *published by Bloomsbury in 1999.*

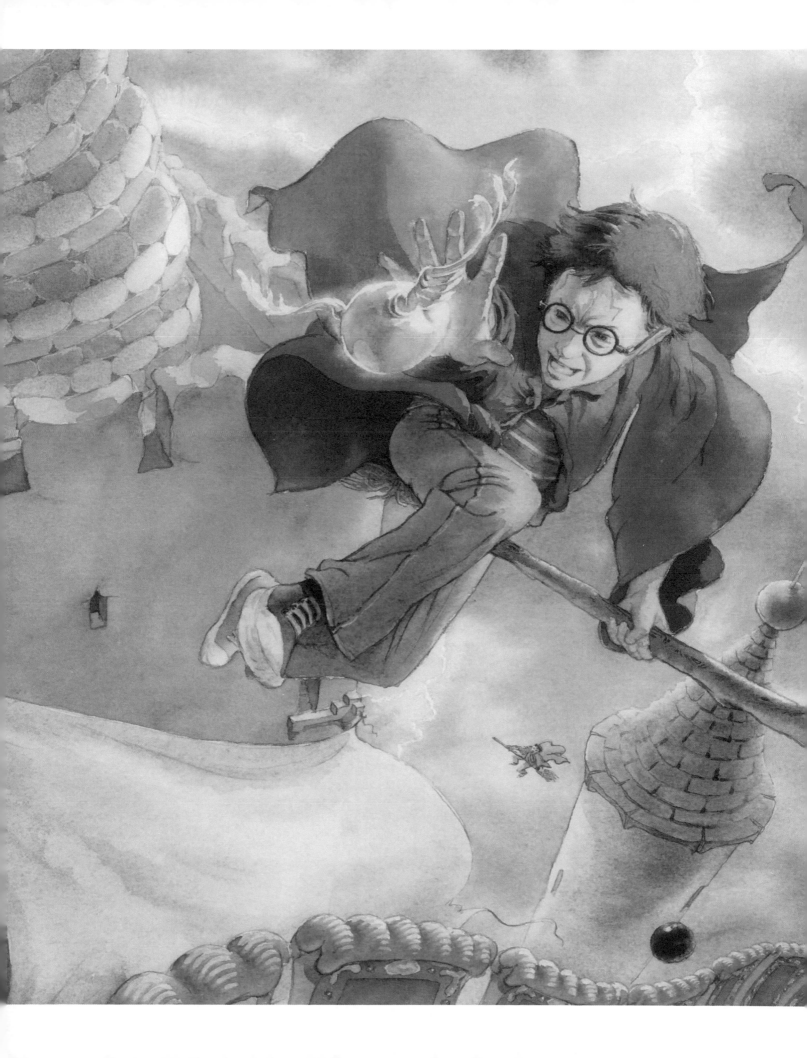

REFINING YOUR TOUCH

BY NOW YOU HAVE AN INCREASED APPRECIATION OF YOUR MATERIALS AND SOME SENSE OF HOW TO RENDER LIGHT AND SHADE. IN THE NEXT FEW PAGES I'M GOING TO INTRODUCE A FEW IDEAS TO TUNE YOUR PRECISION TO A VERY HIGH LEVEL. ONCE AGAIN, TRY NOT TO BE FOCUSED ON THE END RESULT OF THESE EXPERIMENTS — SEE THEM AS PRACTICES THAT YOU CAN ALWAYS PLAY WITH, WHATEVER STAGE YOU ARE AT. I STILL TRY THEM AND WILL CONTINUE TO DO SO, ON AND OFF, TILL THE DAY I STOP DRAWING.

You will need

A QUIET PLACE FREE FROM DISTRACTIONS

AN UPRIGHT DINING CHAIR

A LENGTH OF BAMBOO CANE

A SAW

A SHARP 2B PENCIL

SOME TAPE

AN A3 SHEET OF PAPER

AN ONION, OR OTHER OBJECT

DRAWING FROM A DISTANCE EXERCISE
25–30 minutes

A great experiment in finding how precise you can be with your drawings is to use a much longer pencil. You can achieve this by attaching a pencil to a length of bamboo.

1. Saw between the 'knuckles' of the bamboo cane to find a hollow section that matches the thickness of your pencil. Push a pencil into the core and secure it with tape or pack it out if necessary. You're aiming for a finished length of between 90–120cm (3–4ft).

2. Place your paper on the floor and make sure it can't move – either by clipping it to a board or using a pad. Sit in front of your paper ready to draw. You will need to experiment with how far away your chair is from the drawing. Holding the bamboo as you would any pencil but at the farthest end from the pencil, make a few marks on the paper. The important thing is to find an angle that works. Aim for totally smooth control but avoid resting the bamboo against your leg or arm for support.

3. Draw a few lines on the paper, just to give yourself a sense of control. Vary the angle of your hand and the marks you make until you realize you can have just as much control as you would any normal pencil.

4. Place the onion on your sheet of white paper on the far side of your drawing pad, making sure it is lit from one side. Take yourself through the Sense Exercise on page 23. Observe the detail of light and shade, take some time to do this and see as much detail as you possibly can, since you are now some distance from the onion.

5. Keeping your attention fully present, now draw and shade the onion – taking around 15 minutes. By the end of that time your hand may well be aching, so don't worry if the drawing is not complete. This is a very tough challenge on your focus and attention, so make your movements delicate and precise.

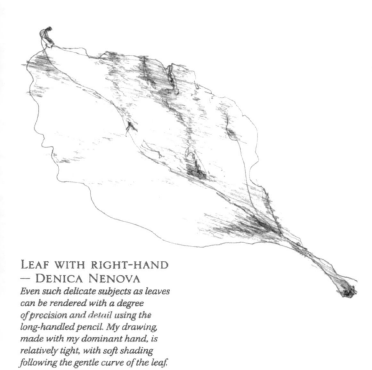

LEAF WITH RIGHT-HAND — DENICA NENOVA
Even such delicate subjects as leaves can be rendered with a degree of precision and detail using the long-handled pencil. My drawing, made with my dominant hand, is relatively tight, with soft shading following the gentle curve of the leaf.

DRAWING FROM A DISTANCE — SAMIRA HARRIS
The loose pencil lines successfully follow the rounded form of the onion, and it is surprising how you can manipulate the pencil from a distance to achieve this result. Samira reinforced the divisions on the onion skin with a pencil, similarly attached to a length of bamboo.

LEAF WITH LEFT-HAND — DENICA NENOVA
This rendition is lighter still, with more of an impression of the overall shape but still retaining a degree of detail and three-dimensionality. Challenging yourself both to draw with your non-dominant hand and with an extended pencil is a great discipline.

YOU CAN ALMOST FEEL THE CRISP TEXTURE OF THE LEAF TIP THROUGH THE DENSITY OF THE PENCIL MARKS

A SOFTLY SCUMBLED TONE ANCHORS THE LEAF TO THE PAPER, MAKING THE IMAGE JUMP OUT

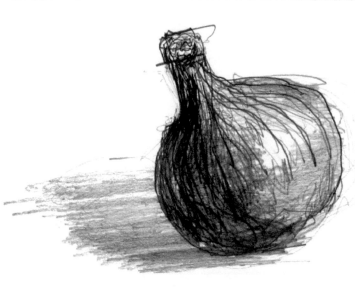

SMALL-SCALE LEAF
Compare this highly-detailed and finished drawing to those of the leaf above. Here, the process of concentration produces an incredibly detailed image, with great attention paid to the textures of the surface, the highlights and shadows, giving it a three-dimensional clarity.

DRAWING SMALL

DRAWING ON THIS SCALE REQUIRES A VERY HIGH LEVEL OF ATTENTION. THESE EXAMPLES WERE COMPLETED BY FRIENDS WHO HAVE BEEN PROFESSIONAL ARTISTS FOR MANY YEARS SO, IF YOU ARE A BEGINNER, DON'T BE DAUNTED IF YOUR ATTEMPT DOESN'T MATCH SOME OF THESE. EVERYONE WHO TRIED IT SAID HOW ENJOYABLE IT WAS TO DO; THE PROCESS IS THE KEY. SPEND SOME TIME HAVING A CLOSE LOOK AT THESE EXAMPLES AND NOTICE THE DIFFERENCES IN MARK-MAKING AND THE VARIED ATTEMPTS TO RENDER THIS SIMPLE FORM IN LIGHT AND SHADE. HOW WELL DO YOU THINK THEY SUCCEED? WHICH IS YOUR FAVOURITE?

You will need

- A QUIET PLACE FREE FROM DISTRACTIONS
- AN UPRIGHT DINING CHAIR
- A VERY SHARP 1B PENCIL
- AN A4 SHEET OF PAPER
- AN APPLE, ONE WITH LITTLE COLOUR VARIATION, NOT TOO DARK OR SHINY

Drawing small makes your task more manageable and you may find it easier to cope with proportion, too.

DRAWING SMALL EXERCISE

20 minutes

This can be a very absorbing exercise. Try it with other objects and in different lighting conditions.

1 Set the apple on a sheet of white paper and light it from one side with a lamp, placed about 30cm (1ft) from your apple.

2 Prepare to draw in the usual way, taking yourself through the Sense Exercise on page 23.

3 Draw a 2.5-cm (1-in) square. In the same way that you drew the pear and pebble, attempt to render your apple exactly but this time within the square. Use your observation to guide your hand and build up the dark tones evenly and precisely. Where is the darkest black? Where is the brightest white?

4 Once again, use a very, very fine touch and all of your powers of attention. Try to draw as much detail as you can see and work fairly fast, even though your drawing is small.

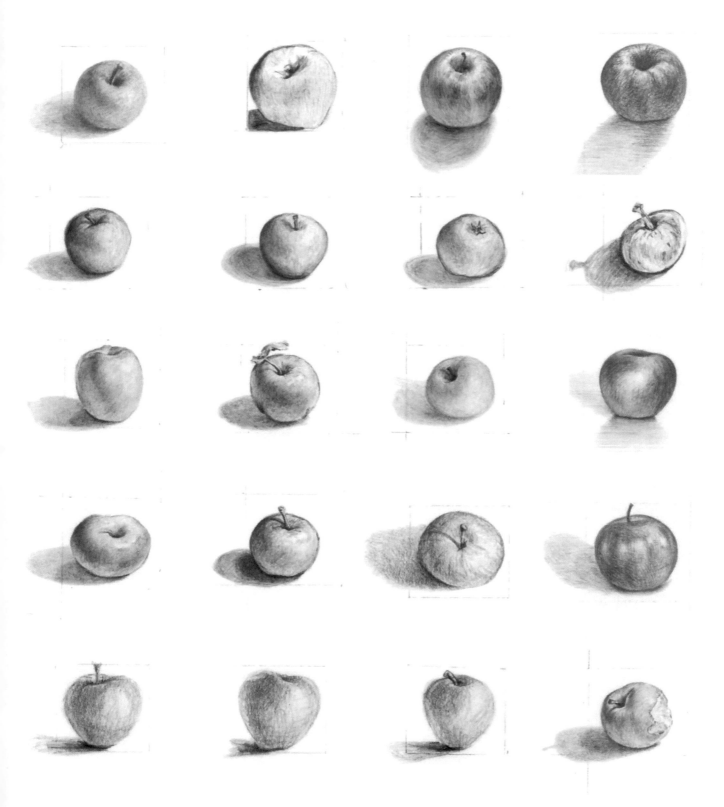

True boldness and power are only to be gained by care. Even in fencing and dancing, all ultimate ease depends on early precision in the commencement; much more in singing or drawing.' JOHN RUSKIN (1819–1900)

USING A DELICATE TOUCH

THE PREVIOUS EXERCISES HAVE USED DIFFERENT MEDIA THAT YOU CAN MANIPULATE WITH RELATIVE EASE BUT IT IS NOW TIME TO PUT YOUR NEW FOUND DELICATE DRAWING SKILLS TO THE TEST BY USING A LESS FORGIVING MEDIUM, A BRUSH.

This exercise with a brush and ink takes extreme precision and a lot of practice; it is not something that is meant to come easily or give you an instant masterpiece. It is worth attempting though, because the focus required of your vision will really help to fine-tune your hand movement.

You could find that you really enjoy the feeling of the brush and if that's the case, then use it as much as you can. To progress, use different-sized brushes and try with papers of varied textures. To fine-tune this fine-tuning you could even try attaching a brush to your length of bamboo (see page 74), the experiments are endless!

You will need

A QUIET PLACE FREE FROM DISTRACTIONS

AN UPRIGHT DINING CHAIR

A NO. 4 BRUSH

SOME BLACK INK

A SHEET OF WATERCOLOUR PAPER

A TWIG, LESS THAN A PENCIL WIDTH WIDE, WITH AT LEAST ONE STEM DIVIDING FROM THE MAIN BRANCH

DELICATE TOUCH EXERCISE

The following exercise demands a highly refined and delicate touch. It can take months of practice to achieve a satisfactory outcome, so please don't focus on the result!

1. Load your brush with ink and draw several practice lines of varying pressures and widths. Go from thin to thick within one line. Explore how much variation you have access to and how subtle your touch must be to achieve it.

2. Vary the amount of ink you start with. Remember, especially when you are starting, under-doing is better than over-doing. Keep your touch light and controlled.

3. Now place your twig against the sheet of white paper. Take a good few minutes to really 'see' the shape that is in front of you. Notice how it tapers. What happens at the joint of another branch? Does it have a character? Are there indentations or 'knuckles'? Invest your passion in seeing all that is in front of you.

4. Take yourself through the Sense Exercise (see page 23). Open your eyes and pick up your brush loaded with ink. Begin drawing and attempt to render the stem of your twig in one brushstroke only – using greater or lesser pressure as the shape becomes thicker or thinner. Try to render each stem with just one brush stroke. Use your full attention – *you will need it*!

5. Again, it takes practice, but you can also gently rotate the brush to distribute the ink differently. Experiment and persist – it is easy to be daunted. Practise faster and slower speeds on successive drawings and let your eyes and the quality of your vision dictate the movement of your hand.

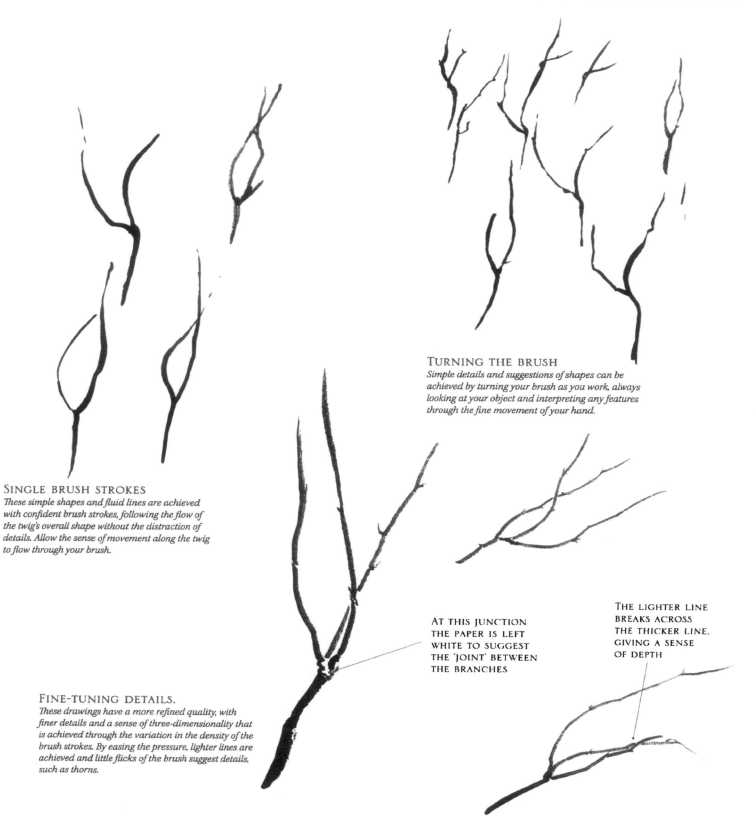

TURNING THE BRUSH

Simple details and suggestions of shapes can be achieved by turning your brush as you work, always looking at your object and interpreting any features through the fine movement of your hand.

SINGLE BRUSH STROKES

These simple shapes and fluid lines are achieved with confident brush strokes, following the flow of the twig's overall shape without the distraction of details. Allow the sense of movement along the twig to flow through your brush.

FINE-TUNING DETAILS.

These drawings have a more refined quality, with finer details and a sense of three-dimensionality that is achieved through the variation in the density of the brush strokes. By easing the pressure, lighter lines are achieved and little flicks of the brush suggest details, such as thorns.

AT THIS JUNCTION
THE PAPER IS LEFT
WHITE TO SUGGEST
THE 'JOINT' BETWEEN
THE BRANCHES

THE LIGHTER LINE
BREAKS ACROSS
THE THICKER LINE,
GIVING A SENSE
OF DEPTH

NEGATIVE SPACE

SO FAR WE HAVE DRAWN OBJECTS IN ISOLATION. WHEN DEVELOPING YOUR ABILITY TO 'REALLY' SEE OR IN COMPOSING A PICTURE, IT CAN BE VALUABLE TO CONSIDER THE SPACE AROUND AN OBJECT — NORMALLY KNOWN AS NEGATIVE SPACE.

This will be discussed in greater detail in the final part of the book. I am including it here as an exercise in fine touch, as it does provide a link between seeing accurately and your imagination. Hopefully, it will encourage you to see negative space everywhere.

You will need

A TREE

A SHEET OF CARD, 30CM (1FT) SQUARE

A SHARP 1B PENCIL

AN ERASER

A DRAWING PEN

SOME INK

AN A3 SHEET OF PAPER

Tip

TAKING SMALL SECTIONS OF COMPLEX OBJECTS, SUCH AS A TREE, CAN MAKE IT MORE MANAGEABLE. NATURE REPEATS SHAPES OR PATTERNS ALL THE TIME, SO ISOLATING PART OF AN OBJECT CAN ALSO HELP YOU UNDERSTAND THE OVERALL PICTURE.

NEGATIVE SPACE EXERCISE

Let's concentrate on precision.

1 Cut a 14-cm (5.5-in) square hole in the card.

2 Find a tree where you can see the branch structure clearly – either a dead one or one with very few leaves – with sky as background. Sit near the tree and hold up your card almost at arm's length. Viewing the tree through the hole, isolate a section of the branches. Move the card around to 'compose' a pattern that attracts you.

3 Once you are happy with your 'composition' through the card, make a drawing of it. This time only draw the spaces between the branches. With the card held up, quickly sketch your rough composition of the main spaces. Complete the detail without holding the card up or your arm will start aching! You are not interested in making a three-dimensional drawing here, so don't worry about branches overlapping – simply make a copy of the spaces they surround. Use your full attention and make the shapes accurate, erasing and starting again if necessary.

4 Bring the drawing back home and retreat to your quiet space. Keep your full attention. With your drawing pen and the paper at an angle, draw over your pencil lines.

5 Draw with great precision – a drawing pen will respond quickly to differing pressures. For this exercise aim to keep the line width the same throughout the whole drawing, keeping a very light and precise touch.

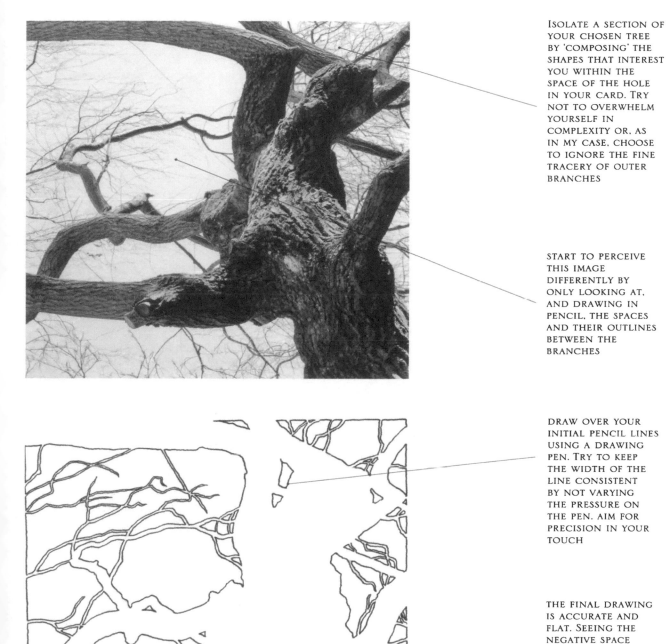

ISOLATE A SECTION OF
YOUR CHOSEN TREE
BY 'COMPOSING' THE
SHAPES THAT INTEREST
YOU WITHIN THE
SPACE OF THE HOLE
IN YOUR CARD. TRY
NOT TO OVERWHELM
YOURSELF IN
COMPLEXITY OR, AS
IN MY CASE, CHOOSE
TO IGNORE THE FINE
TRACERY OF OUTER
BRANCHES

START TO PERCEIVE
THIS IMAGE
DIFFERENTLY BY
ONLY LOOKING AT,
AND DRAWING IN
PENCIL, THE SPACES
AND THEIR OUTLINES
BETWEEN THE
BRANCHES

DRAW OVER YOUR
INITIAL PENCIL LINES
USING A DRAWING
PEN. TRY TO KEEP
THE WIDTH OF THE
LINE CONSISTENT
BY NOT VARYING
THE PRESSURE ON
THE PEN. AIM FOR
PRECISION IN YOUR
TOUCH

THE FINAL DRAWING
IS ACCURATE AND
FLAT. SEEING THE
NEGATIVE SPACE
IN THIS WAY AND
REMOVING THE
THREE-DIMENSIONAL
QUALITIES GIVES YOU
A CHANCE TO FOCUS
YOUR ATTENTION
ON PATTERN AND
ARRANGEMENT ON
THE PAGE. NOTE
TOO THE PLEASING
BALANCE BETWEEN
SPACE AND DETAIL

FEELING FACES

UNTIL NOW YOU HAVE EXPLORED THE IDEA THAT YOUR DRAWINGS WILL REFLECT YOUR EMOTIONS AND THE STATE OF YOUR SENSES. YOU WILL HAVE A GOOD PERCEPTION OF HOW CONSIDERED, FOCUSED ATTENTION, COMBINED WITH A FINE TOUCH, CAN LIBERATE THE IMAGINATION. THE NEXT EXERCISE WILL ALLOW YOU TO DIP YOUR TOES FURTHER INTO THIS PROCESS AND INTRODUCE THE APPARENTLY DIFFICULT SUBJECT OF FACES.

Drawing faces is seen as one of the greatest challenges and is indeed a daunting task – there is an all-consuming tendency to focus on the final result and inevitably we want to flatter and are frightened of offending. Think of a face that you see every day, perhaps your parent or partner. We think we know a familiar face, but what happens if you come to draw that person when they are not present? Could you do that? I know that I would struggle. Although most human faces are made up of very simple features – just two eyes, a nose, a mouth and an overall shape – they all have endless and infinitely subtle variations.

An effective way to help you observe the differences is to allow your looking to be free of thought and to focus your attention on the other senses – or fully on one sense. This part of the book is all about your sense of touch, so this exercise brings together a way of 'seeing' and drawing a face through literally touching your subject and removing the sense of sight completely. With eyes closed, your sense of touch is your only guide.

You will need

A QUIET PLACE FREE FROM DISTRACTIONS
AN UPRIGHT DINING CHAIR
AN A3 SHEET OR PAD OF WHITE PAPER
A GRAPHITE PENCIL

FEELING FACES EXERCISE
As much time as you need

Choose your parent, partner or a very close friend as your subject. This is a very intimate task – make sure your partner knows exactly what they are letting themselves in for. Be very quick with these drawings to begin with – it will give you less chance to think!

1 Arrange yourself so you can draw and reach your partner's face with your other hand. Complete the Sense Exercise on page 23 to focus your attention. As you bring yourself out of the sense exercise do not open your eyes but have your partner guide your non-drawing hand to their face.

2 Simply feel the shapes beneath your fingers, keeping your eyes closed. Take at least a minute over this to get a sense of the features in front of you, don't think about it.

3 Now, still touching your partner's face, begin drawing what you feel, keeping your eyes closed and your attention on your sense of touch – keep your touch light in both hands! Once again, this is practice in not trying to create; just enjoy the process and let the drawing draw itself. Now try swapping hands.

4 Take some time to see your drawing differently. Is there an eyebrow that has character? Are the lips three-dimensional? How is the overall head shape? Look for moments where you have met the shape and try to remember the quality of attention you felt when that happened.

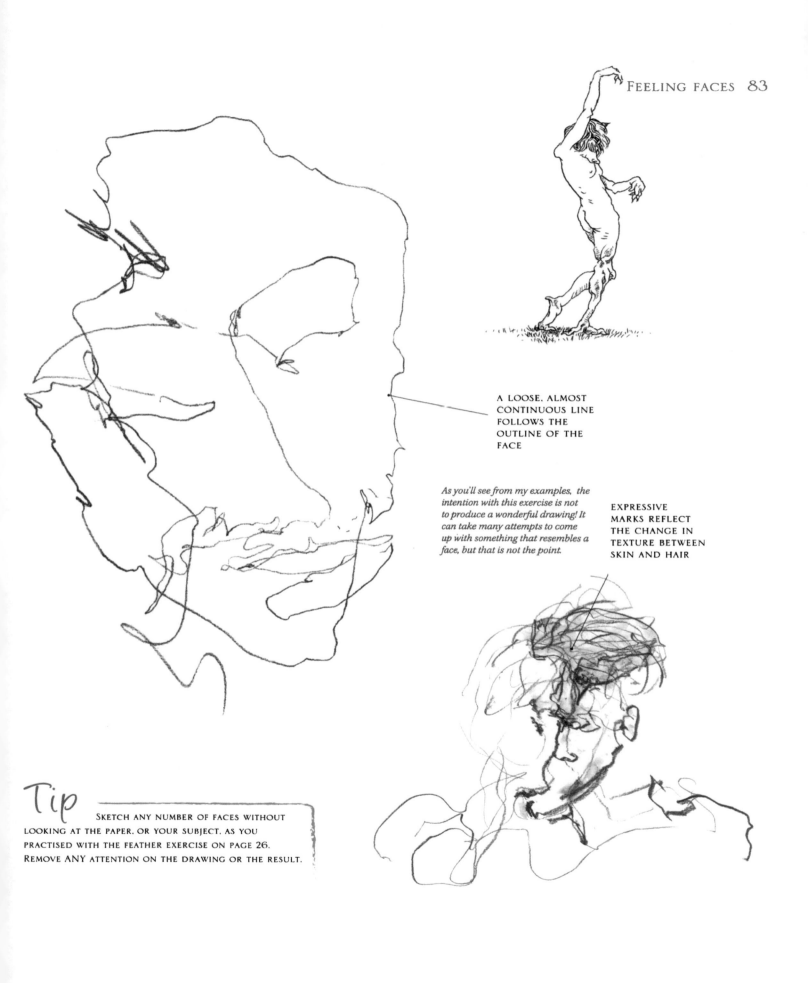

A LOOSE, ALMOST
CONTINUOUS LINE
FOLLOWS THE
OUTLINE OF THE
FACE

*As you'll see from my examples, the
intention with this exercise is not
to produce a wonderful drawing! It
can take many attempts to come
up with something that resembles a
face, but that is not the point.*

EXPRESSIVE
MARKS REFLECT
THE CHANGE IN
TEXTURE BETWEEN
SKIN AND HAIR

Tip

SKETCH ANY NUMBER OF FACES WITHOUT
LOOKING AT THE PAPER, OR YOUR SUBJECT, AS YOU
PRACTISED WITH THE FEATHER EXERCISE ON PAGE 26.
REMOVE ANY ATTENTION ON THE DRAWING OR THE RESULT.

'Now do you see that the eye embraces the beauty of the whole world? It counsels and corrects all the arts of mankind... it is the prince of mathematics, and the sciences founded on it are absolutely certain. ... it has given birth to architecture and to the divine art of painting.' LEONARDO DA VINCI (1452—1519)

THE MASTERS

GIVE YOURSELF A TREAT AND, AS MUCH AS YOU CAN, STUDY THE DRAWINGS OF MASTERS. TRY TO SEE ORIGINAL WORKS RATHER THAN THE PRINTED PAGE. SEE THEM IN THE SAME WAY THAT YOU HAVE LEARNT THE DRAWING EXERCISES IN THIS BOOK — USE YOUR FULL ATTENTION. EXAMINE THEM, NOT BECAUSE YOU WANT TO DRAW LIKE THEM BUT BECAUSE IT WILL HELP TRAIN YOUR EYE TO NOTICE A SUBTLE AND DELICATE TOUCH AND HOW THEY COPED WITH THE PROBLEMS THAT YOU WILL FACE. GIVE YOURSELF AN INCREASING SENSE OF WONDER AS TO HOW LINE CAN INFORM A SHAPE AND OF HOW SIMPLE ECONOMY IS ALWAYS MORE EFFECTIVE THAN OVER-DOING IT.

ALPHONSE MUCHA

Ever since seeing works by the fore-runner of art nouveau, I have been impressed by the quality of his drawing. Again, I'm aware of how such a simple but bold outline can convey so much about form and Mucha was a master of using the design of the space around his figures to inform their characters. Have a look too at the astounding delicacy of drawing in these studies.

Sarah Bernhardt (1844-1923) as Medee at the Theatre de la Renaissance, 1898 (colour litho) by Mucha, Alphonse Marie (1860-1939) Mucha Trust/ The Bridgeman Art Library

LEONARDO DA VINCI

Scientist, artist, inventor... The profound and original knowledge of Leonardo shines through his extraordinary drawings. Consider the movement, form and character of the unicorn and yet marvel at its simplicity.

A Unicorn Dipping its Horn into a Pool of Water (pen & ink and metal point on paper) by Vinci, Leonardo da (1452-1519) © Ashmolean Museum, University of Oxford, UK/ The Bridgeman Art Library

ARTHUR RACKHAM

Rackham really was a master drawer. The printed page will never completely represent the quality of an original and this is certainly true of his work. The power, beauty and panache of Rackham's line has rarely been equalled.

"In the Forest with a Barrel" from 'Rip Van Winkle' written by Washington Irving (1783-1859), 1905 by Rackham, Arthur (1867-1939) Private Collection/ © The Fine Art Society, London, UK/ The Bridgeman Art Library

MICHELANGELO

If you have the chance to see any drawings by Michelangelo you may find it surprising that most were created as preparation sketches for the sculptures or paintings for which he is famous. Actually, he destroyed many hundreds of his drawings, since he wanted the public to see only the final piece.

It is hard to describe the quality and fineness of line which a lifetime of total dedication can bring forth.

The detail, subtlety and power of these works may well bring a tear to your eye – they do to mine.

Ideal Head of a Woman. c.1525–8.

The Fall of Phaeton. 1533.

PART THREE — FROM IMAGINATION
TO PAGE

Drawing from the imagination is about walking the paths you fear to tread and to even go beyond your dreams.

HOW DO YOU DRAW FROM YOUR IMAGINATION? DRAWING FROM YOUR IMAGINATION IS A SUBJECT THAT COULD FILL VOLUMES AND WE CAN ONLY REALLY BEGIN TO SCRATCH THE SURFACE HERE. BUT THE REFLECTION OF YOUR NATURE THROUGH YOUR DRAWINGS AND COMPOSITIONS IS A MAGICAL WORLD OF INFINITE POSSIBILITY, DEEPENING COMMUNICATION WITH OTHERS. I HOPE THAT THIS CHAPTER WILL ENCOURAGE YOU TO BE INSPIRED.

As we have already discussed, when the mind is absent there is 'room' for creativity to breathe and emerge. Of course, we must also admit that the mind can and does conjure imagery, often wild and fantastic and of a nature which compels us to communicate. The challenge is to match the skill of the hand with the vision of the imagination. Having played with how we see and the finesse of touch in the first two sections, I'm hopeful that you will now have some confidence in transferring your vision to the page. The following pages will make a few practical suggestions as to how this knowledge can be applied to developing characters and bringing them to life in finished pictures.

There is now an obvious dilemma. Attention so far has been on your journey, not the result. With the focus now on creating a piece of 'finished' art, there is a great danger of losing your magical, intuitive essence. We can minimize this danger by continuing to hold the idea that the journey is paramount. Allow the result to find you rather than being led by the anxiety to find it, by making certain that the process is solid and good. Ultimately, this will be a far more rewarding approach and one which will fully unearth your incredible abilities.

Hope.

FREEING YOUR IMAGINATION

It is only by drawing often, drawing everything, drawing incessantly that one fine day you discover to your surprise that you have rendered something in its true character.' CAMILLE PISSARRO (1831–1903)

YOUR DRAWING MEDIUM, BE IT PENCIL, PEN OR CHARCOAL, IS THE CONDUIT BETWEEN YOUR IMAGINATION AND THE PAGE. TRAINING YOURSELF TO KEEP THIS CONDUIT FLOWING FREELY WILL ENABLE YOUR IDEAS TO MATERIALIZE, GROW AND DEVELOP. SKETCHING IDEAS, THOUGHTS, IMPRESSIONS, PEOPLE, ANIMALS, FLORA AND FAUNA, IN FACT ANYTHING THAT INTERESTS OR INSPIRES YOU, WILL KEEP YOUR CREATIVITY ALIVE AND FREE YOUR IMAGINATION. THE NEXT FEW PAGES LOOK AT WAYS OF CHANNELLING YOUR THOUGHTS, THROUGH SKETCHES, DOODLES AND EVEN BY TAKING A WALK TO AWAKEN YOUR IMAGINATION TO NEW POSSIBILITIES.

Tip

CHOOSE A SKETCHBOOK THAT FEELS COMFORTABLE TO CARRY WITH YOU — ONE THAT WILL ATTRACT YOU AND ENCOURAGE YOU TO FILL IT WITH DRAWINGS! SPIRAL-BOUND SKETCHBOOKS LAST LONGER AND ARE EASIER TO HANDLE. USE A PEN OR PENCIL, OR ANYTHING THAT COMES TO HAND, TO RECORD YOUR IMPRESSIONS WITH SPONTANEITY AND SPEED, IF CALLED FOR.

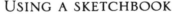

USING A SKETCHBOOK

A sketchbook is your personal, visual diary of the world which you inhabit. It is your mobile studio or your excuse to simply jot down ideas in those moments when something you see arrests you completely and time stands still. It is your opportunity to be still and fully absorbed in whatever captures your imagination, any time, any place. You can spend a few minutes or an hour, or not if you feel like it. It's your time – a safe space to explore your feelings, free of judgement or the opinions of others.

USE YOUR SKETCHBOOK TO:

• **Make** small **studies**, sketches, **ideas** for paintings and compositions, **thumbnail** sketches
• **Collect** anything that **takes** your **eye**
• **Write** your **thoughts** or surround your drawings with detailed **annotations**

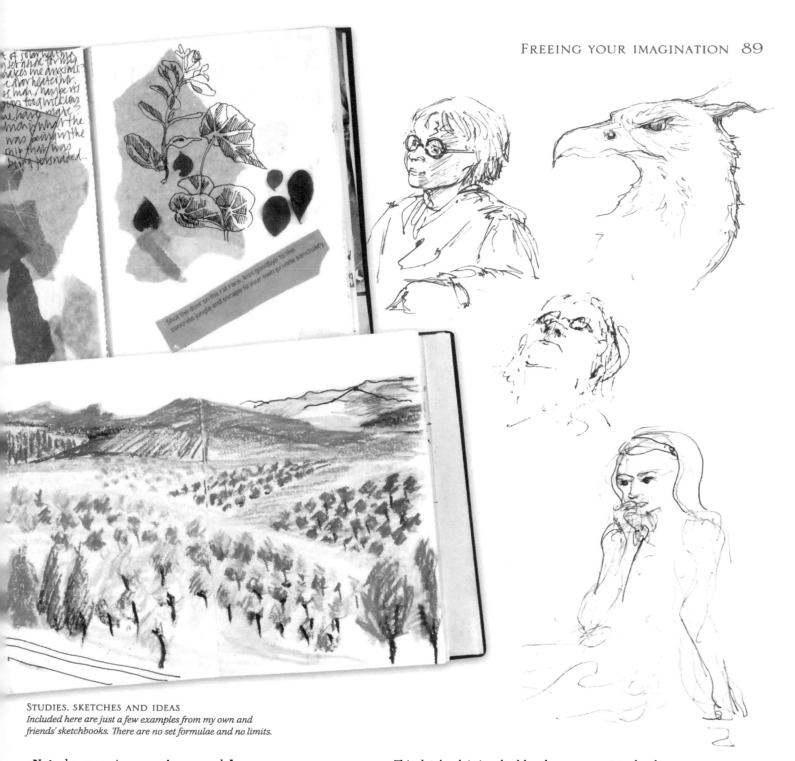

STUDIES, SKETCHES AND IDEAS
*Included here are just a few examples from my own and
friends' sketchbooks. There are no set formulae and no limits.*

• **Note** down passing **experiences** and **dreams**

Your sketchbook is a place where you are in total control. It's your
haven where all is possible and nothing is too far-fetched; where
ideas can form from nothing and return to nothing without a
care in the world. It's your best-friend in a crisis... and it's your
databank of coveted treasures which, revisited years later,
transport you, child-like, to forgotten secret cupboards.

This databank is invaluable when you want to develop an
idea or a character, and is especially useful to remind you of the
immediacy and vitality of an image when working on a finished
picture. Compare any artist's sketchbook against their final work
and you will very often notice that the final piece displays an
absence of the vitality that the sketches were brimming with.

THE ART OF DOODLING

MOST PEOPLE HAVE DOODLED AT ONE TIME OR ANOTHER. I TEND TO SUCCUMB TO SCRIBBLING WHEN I'M ON THE PHONE TO CLIENTS OR GOOD FRIENDS; DIFFERENT FRIENDS PRODUCE DIFFERENT DOODLES. A DOODLE IS SO EASY AND EFFORTLESSLY MADE, ON A SCRAP OF PAPER HERE, THE BACK OF AN ENVELOPE THERE, AND IT CAN BE JUST AS EASILY DISCARDED. YET IT IS IMPORTANT AS A MEANS OF EXPRESSION — AN UNINHIBITED GATEWAY TO YOUR SUBCONSCIOUS THAT CAN SOMETIMES LEAD TO EXCITING DISCOVERIES. THERE IS NO DESIRE FOR OUTCOME AND PERHAPS EVEN MORE IMPORTANTLY, THERE IS ALSO NO FEAR THAT YOU WILL BE JUDGED AS AN ARTIST ON THE STRENGTH OF A DOODLE. SO ALWAYS DOODLE. HOPEFULLY THE PRACTICE WILL SEEP INTO YOUR OTHER DRAWINGS AND ALLOW YOU TO STROLL ALONG EVER-NEW PATHWAYS OF SEEING.

THE VALUE OF DOODLES

• The **creation** of them gives you the **space** to realize that it is OK to be **free** of **control**.

• Through the **simple** art of **scribbling**, you can understand what it is not to try and to be **free** from the fear of **expectation**.

• With an exclusive **emphasis** on the **journey**, not the result, you have complete artistic **freedom** and a space to **explore** the **subconsious**.

Doodling is a doorway to your very soul — your creative consciousness set free and unleashed!

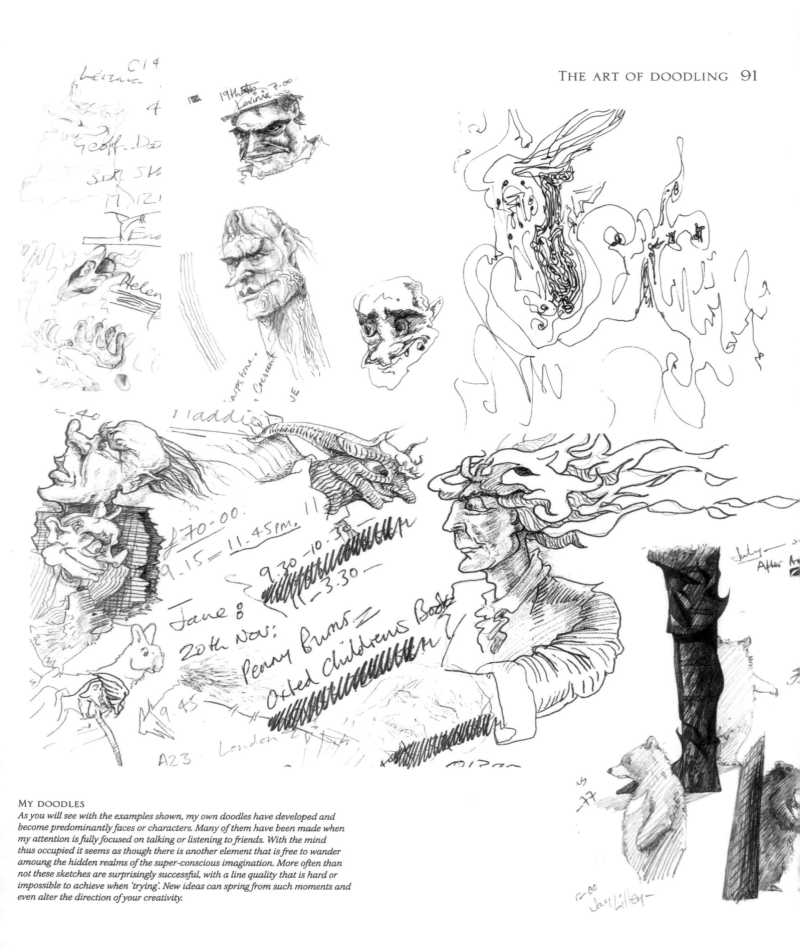

MY DOODLES

As you will see with the examples shown, my own doodles have developed and become predominantly faces or characters. Many of them have been made when my attention is fully focused on talking or listening to friends. With the mind thus occupied it seems as though there is another element that is free to wander among the hidden realms of the super-conscious imagination. More often than not these sketches are surprisingly successful, with a line quality that is hard or impossible to achieve when 'trying'. New ideas can spring from such moments and even alter the direction of your creativity.

The air is full of an infinite number of images of the things which are distributed through it, and all of these are represented in all, all in one, and all in each.' LEONARDO DA VINCI (1452–1519)

OPENING YOUR MIND

THE BASIC POINT OF THIS BOOK, IF YOU HAVEN'T GRASPED IT ALREADY, IS TO ENCOURAGE YOU TO SEE DIFFERENTLY; TO SEE BEYOND THE OBVIOUS TO DEEPER TRUTHS... TO HAVE YOUR CAKE AND EAT IT! SEEING IS THE EATING; DRAWING IS THE CAKE.

The following is an exercise in seeing – in accepting the challenge of noticing more and seeing yourself. It is intended to fire-up your ability to see and to stock your unique and immense treasure-house of forms and images; the key to which will be your imagination. Typically, when we take a walk in nature we have agendas. Even if we recognize a need to relax, we may have a destination in mind, a time to be back for, a problem to resolve, a friend to talk to, a dog to walk... All of these are curtains drawn across the eyes, a mist through which reality may only be dimly seen.

FREE YOUR IMAGINATION EXERCISE

Calling on your imagination is not as difficult as some of us fear. Visualize yourself as a bear standing in front of a vast landscape. Where you are standing the grass is long and damp. In the foreground are three large rocks as big as a house and beyond that a dozen trees grouped together. In the middle distance is a river, its silvery form reflecting the sun's rays like a white ribbon. More trees rise from behind the river in a tumbling forest and in the far distance above the trees, green hills roll towards an expansive mountain range which soars away as far as the eye can see.

How much of that landscape did you visualize? Did your bear walk through the space? Did you see where the river was going or where the mountains led to? Did you realize that what you see isn't all that is there? Did you sense that there are ever-new lands beyond the relatively small world which you inhabit?

A WALK IN NATURE EXERCISE

As long as you need

Find yourself a space in nature where you can spend some time. Choose a place that is as wild as you can make it – free from the intrusion of other people. Pick a day where you have no time restrictions. A park will be fine, you will simply have a few more challenges for your attention. Whenever I practise this exercise, all sense of time is lost and hours can pass without notice. Give yourself the chance to 'disappear' in this way as many times as you can afford. Every other time, take your sketchbook with you and record your experiences.

1 Go to where you will start your walk. Sit down and take yourself through the Sense Exercise on page 25. On its completion, begin walking, being aware of when your thoughts absorb you. Let the landscape and your intuition dictate the direction that you move towards and re-fill your mind. Walk where you are drawn to, which maybe away from the main path.

2 As you proceed, be guided by your senses. Open all of your senses fully and keep your attention on them, to quieten your mind in the same way that you have practised in the Sense Exercise.

3 Notice any and all of the subtle smells around you, the feel of the weather on your skin as you pass from one place to another, the taste of the air, the sounds that surround and envelop you.

4 Allow your attention to be captivated by all that attracts you – the bend of a limb of a tree, the wafting sense of a new aroma, the print of an animal in the earth, the feeling of the soil as you stop to run your hand across its surface, the strange form of a plant, and on and on.

5 When it feels right, take a moment to simply sit still and practise owl vision from page 25. How still can you be? How much movement can you perceive?

6 All the time listen. Listen deeply. Let everything keep talking to you – attracting you, bending your path. Be aware of becoming attached to one way and let yourself be overtaken by this new direction, this new interest. Move ever more slowly and see everything.

7 Imagine that you are a deer, on a highly-tuned sense-alert. Look up, look around, climb a tree, lie on the earth and look from ground level. See if you can allow yourself to become so absorbed by all that you experience, that you stop thinking completely and become instinctive.

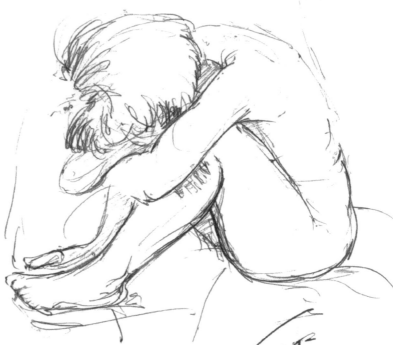

DRAWING FROM LIFE

IN COMPOSING AN IMAGE FROM THE IMAGINATION, ESPECIALLY IF YOU ARE CREATING A FANTASY CHARACTER, THERE COMES A POINT WHERE CERTAIN ELEMENTS FEEL OUT OF BALANCE AND WE CANNOT MAKE THEM LOOK 'RIGHT'. REFERENCE IS THE ANSWER — BOTH IN TWO- AND THREE-DIMENSIONS.

Finding reference material in the information age is not difficult. We are bombarded with imagery on the internet, in books, in photographs, magazines, TV, DVDs, film and so on. All of these are amazing resources and we can consider ourselves very fortunate to have them at our fingertips. However, there is a but and it's a big one! If you only use these sources then your drawings will be forever flat because, good as they are, they only exist in two dimensions.

REAL-LIFE REFERENCE

There is nothing to beat first-hand reference or drawing from life. Since the above sources are so easy to access, it can be tempting to over-use them at the expense of life drawing. It takes a bit more effort to find the right model and, as with the bears in some of my illustrations, your subject may not sit still long enough to be drawn! A photograph or any other flat medium can be seen as the easier option. If you are a slave to this habit (and many of us are or will be at some time), then make it a point to force yourself free of it and make studies from life.

Tip

IF YOU NEED FIGURE REFERENCE, DON'T BE DISCOURAGED IF A MODEL ISN'T TO HAND. USE YOURSELF. YOU ARE ALWAYS AVAILABLE AND YOU ARE THE BEST SOURCE OF REALLY 'FEELING' THAT WHICH YOU WISH TO CONVEY.

When your pet is sleeping you have the chance to complete a more detailed study. This portrait of my dog was completed many years ago but I still like the sense of form, balanced by fine detail.

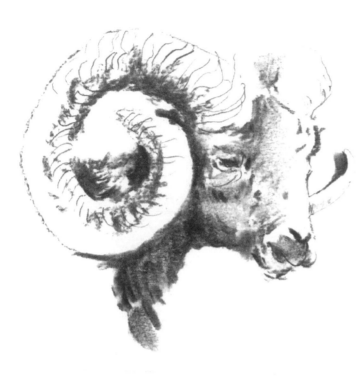

Left: Drawn with charcoal and pencil in less than 10 minutes. The weight of the charcoal line is in a tension with the fine-ness of the pencil line; an effective way to render form quickly.

If you have an obvious need then search out specific reference but you could also devote an hour a week for example, to practising detailed drawings of the things that interest you.

NEW DISCOVERIES

Even if you never use these studies again they will inform the way you see and allow you to discover how things work. This discipline will breathe life into any drawing you do that comes direct from the imagination. The reverse is also true in that you will set your creative mind buzzing with new forms and detail – the benefits are immeasurable. There is always something immediate and true that is instantly perceivable in a drawing made from life. Recognize that it is life and that you have performed a miracle by finding its form on a flat surface.

Your imagination may have created a character that draws on human, animal, plant or sea life references. To draw it with confidence and make it appear convincing, it is worth studying the different elements from which it sprung. Take your sketchbook and venture out to make studies from life. Try:

- zoos
- farms
- pets
- aquariums
- family and friends
- cafés
- train or bus stations
- shopping malls
- museums, where models of extinct species may help to inspire

Below: A friend found this buzzard wing and gave me a rare opportunity through sketching to really see how the feathers of a wing actually work and slide together.

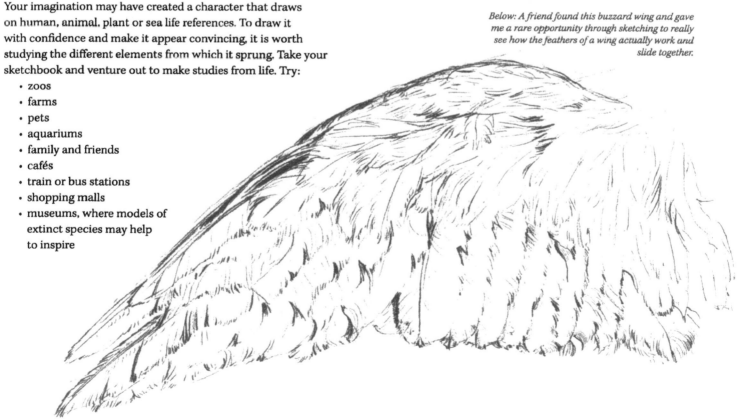

DEVELOPING A CHARACTER

ONCE YOU ARE CONFIDENT THAT YOU CAN MAKE YOUR CHARACTER APPEAR CONVINCING IN 3D, IT IS TIME TO DEVELOP ITS PERSONALITY OR STORY. CHARACTERIZATION CAN TAKE COUNTLESS FORMS — THE LIMITS ARE ONLY YOUR IMAGINATION. A CHARACTER CAN, OF COURSE, ORIGINATE IN MYRIAD WAYS BUT FROM ONLY TWO BASIC SOURCES: DIRECT FROM THE IMAGINATION AND AS A RESPONSE TO SOMETHING ELSE, SUCH AS A PIECE OF WRITING, POETRY, MUSIC, OR, AS IN THE CASE OF A LOT OF MY WORK, AN ILLUSTRATION BRIEF.

Wherever the inspiration springs from, the aim is to make believable whatever or whoever grows from the end of your pen. It is not enough to create the character. It must move. It must be able to sustain itself; to hold things; to inhabit a world and interact with other characters. Exploring the potential of characterization is a great challenge and one which will give full reign to your imagination.

SIMPLE CHARACTERS

The following examples are not a copying exercise, rather a guide to show the process of characterization using bears from a book series that I originated. I would recommend following the process with a character of your own invention – simply substitute your character for my bear.

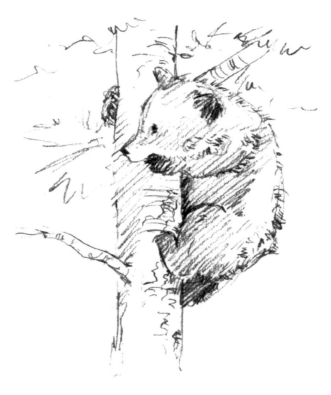

SKETCHING IN THE WILD
I filled my sketchbooks with close observations of the bears in their natural habitat, recording poses and details of fur and paws. Some images I put into context, climbing a tree for example, and in others I looked at how the bears moved, sat and stood – all basic reference points for putting my characters into different contexts within a story.

OBSERVATION

In the case of these bears, the first thing I did was to visit Canada. Halfway between Vancouver and Alaska is a very wild and remote island, where one in ten of the Black Bears is white. It is something of a natural mystery; perfect for the book that I was writing which had a black and a white bear as the main characters. On the island I observed a lot of bears. I saw how they gripped and clambered on slippery rocks and how they gently and powerfully heaved themselves through torrents of water. I saw how they caught fish by 'snorkelling'; how they lumbered through the dense forest; how they interacted when other bears were present; how they climbed; how they 'handled' the fish and the way their snouts wrinkled when eating them and how rustling bushes betrayed their presence. I saw all of these things and took hours of video.

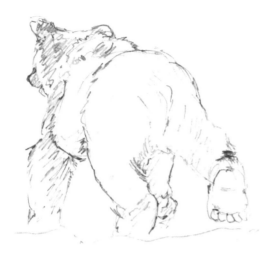

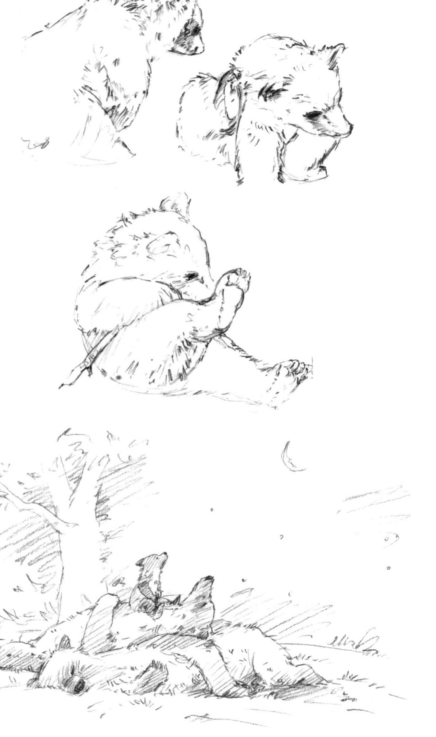

GATHERING REFERENCE

On my return home I made many sketches from the reference I had gathered. After some time, I realized I had lost some of the 'essence' of the bears. So I visited Whipsnade Wild Animal Park to draw and see again the 'real' thing.

CHARACTER ANALYSIS

Then I started to create sketches that asked questions about how to 'humanize' these characters. How would they row a boat? Would they fish like bears or like humans? How could they do human-like things and yet still be bears? I was certain I wanted them to retain their 'bear-ness' and not to be in any way cartoon-like. So there was to be no exaggeration of features; their human-ness would be subtle.

HUMANIZING THE BEARS

My next stage was to start to add human characteristics to the bears, but without changing their features. I tried them in different scenarios – doing human things like carrying a bag of food – but without clothes or changes to their features. This method of implication through association is a simple way to place your character in an unusual context, creating a fantasy element.

PUTTING IT IN CONTEXT

The first image that these bears were destined for is called 'Gone Fishing', so I had a context and the next guide for the characterization. The image was the forerunner for a series of books entitled *Three Bears*. Initially, these were aimed at very young children and had a very simple storyline.

Through the practice of producing such a lot of sketches I developed the ability to 'manipulate' my bears to where I wanted them. With the white bear, for example, I could imagine for myself what it would be like to fall asleep, nose nearly touching the water and slumped in a boat which was too small. Although this book is not the place to talk of colour, the use of gentle blues and greens helps the atmosphere of peacefulness, as does the composition of keeping the characters in the centre of the image and their own world.

GONE FISHING
This was the first published appearance of my bears and was produced as a poster. As it was setting the scene for the book series, I wanted it to reflect the characters strongly. We can identify with bears who are able to fish like humans but are silly enough to have fallen asleep on the job, much to the fishes' amusement. So in one image a fairly complex situation has begun to develop.

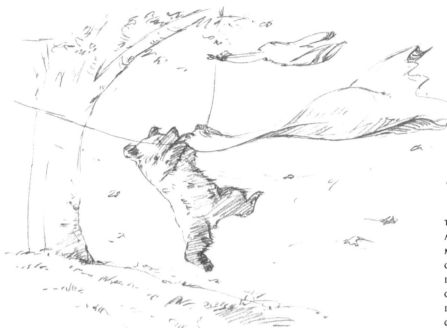

One of my challenges was to have the bears believably play with a kite. So I reached for my kite and played with it – remembering and imagining how it felt to be child-like (the bears themselves are not meant to be very old).

Gradually, throughout this process the sketches came to feel more and more real.

Tip

ALWAYS BEGIN WITH AN IDEA OF THE END RESULT, THEN SET IT ASIDE AND FOCUS ALL OF YOUR ATTENTION ON THE JOURNEY — YOU MAY SURPRISE YOUR OWN IMAGINATION AND OUT OF NOWHERE GIVE LIFE TO AN ORIGINAL IDEA. ARTISTS AND MUSICIANS OFTEN SPEAK OF 'GETTING OUT OF THE WAY' AND LETTING IDEAS SPEAK 'THROUGH' THEM. SUCH MOMENTS OF SPONTANEOUS MAGIC WILL CERTAINLY BE TREASURED AND ARE HIGHLY LIKELY TO BE RECOGNIZED BY OTHERS WHEN THEY RESPOND TO YOUR WORK.

Wrong and right

BEAR AND KITE

There is an example of this 'idea-that-came-from-nowhere' in Bear and Kite, a book of rhyming opposites. In searching for appropriate images to sum up the words, the spread for 'wrong' and 'right' proved interesting. The 'right' way to fly a kite is obvious but the 'wrong' way could be shown in countless variations. The image of the white bear trying to 'fly' the black bear arose surprisingly and spontaneously from beyond conscious thought. I love it as a solution because it lifts the book out of the ordinary – pure fantasy but very funny.

COMPLEX CHARACTERS

THESE DRAWINGS AND IMAGES SHOW MY JOURNEY IN DEVELOPING THE STORY AND CHARACTER BEHIND THE HORSE. THE PROCESS INVOLVED USING MYSELF AS A MODEL AND THEN CHANGING THE SEX AND SPECIES OF THE CHARACTER, PUTTING THEM IN A SETTING AND ADDING PROPS OR ACCESSORIES AND AN AIR OF TENSION AND EXPECTATION. BY KEEPING ALL THESE DISPARATE ELEMENTS TOGETHER AND MOVING TOWARD THE SAME CONCLUSION, YOU WILL START TO MASTER THE ART OF FANTASY DRAWING.

If Only Harriet had Opened her Eyes

CLIFF TURNS INTO A HORSE!

Here's another example of how a character can develop. Take a look at the horse in my painting 'If only Harriet had opened her eyes'. The horse is the main object of interest. By looking closer, however, you can see that danger lurks in the trees. The image relies on the fact that you, as the viewer, can anticipate the next scene. So for the main character I wanted a picture of innocence and a pose that suggested complete unawareness of what is about to take place. This is the process that I went through to develop the character and put it in place in the complexity of the scene.

Tip USING AN ANIMAL RATHER THAN A MORE SPECIFIC HUMAN, WIDENS THE SCOPE FOR SYMPATHY BUT ALSO CREATES A SAFE DISTANCE FOR THE VIEWER.

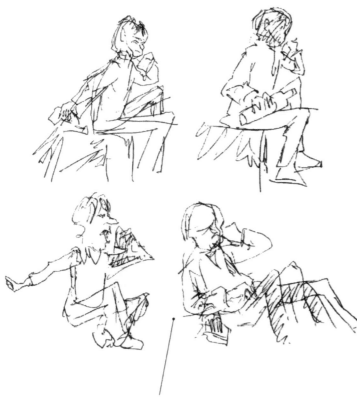

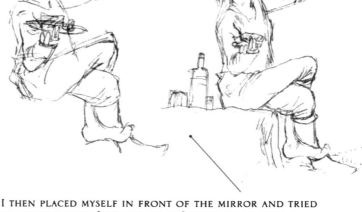

I THEN PLACED MYSELF IN FRONT OF THE MIRROR AND TRIED TO IMAGINE WHAT I WOULD DO IF I WERE ALONE WITH A LARGE CHOCOLATE CAKE, IN THE MIDDLE OF A FOREST. I NOW DECIDED THAT I WANTED A STATEMENT THAT SUGGESTED TOTAL ABSORPTION WITH THE FOOD: THE CALM BEFORE THE STORM. I MADE TWO SKETCHES OF MYSELF, WHICH SOMEHOW LED ME TO THINK THAT MY CHARACTER SHOULD BE A YOUNG GIRL.

FIRSTLY, I DREW A SERIES OF ROUGH SKETCHES WITH NO REFERENCE, TO FIND A POSE THAT SUPPORTED THIS CHARACTER'S ROLE. WITHIN THREE OR FOUR DRAWINGS (SOMETIMES IT WILL TAKE A LOT MORE!) IT BECAME CLEAR THAT IT WOULD AID THE ATMOSPHERE OF INNOCENCE IF THIS FIGURE WAS PRE-OCCUPIED BY ITS ACTIVITY. AFTER HALF A DOZEN DRAWINGS I DECIDED THAT IT COULD BE SELF-ABSORBED IN EATING.

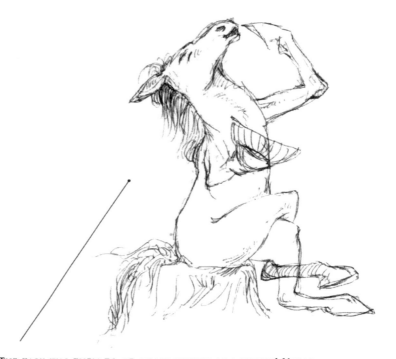

ON REFLECTION I FELT THAT IT WOULD CREATE MORE SYMPATHY IF THE CHARACTER WAS AN ANIMAL. IF YOU ARE A YOUNG GIRL, FOR INSTANCE, YOU MIGHT EASILY IDENTIFY WITH THE HEROINE, BUT IF YOU ARE A BOY OR AN ADULT, YOU WOULD PROBABLY BE LESS SYMPATHETIC. THE WHOLE SCENE IS OUT OF THE ORDINARY SO A CHARACTER THAT STRETCHED BELIEVABILITY WAS CALLED FOR. A HORSE SEEMED WELL SUITED. AFTER ALL, HOW MANY TIMES HAVE YOU SEEN A HORSE ADOPT THE CHOSEN POSE?

THE TASK WAS THEN TO RE-DRAW MYSELF AS A HORSE! USING KNOWLEDGE GAINED FROM MANY STUDIES OF HORSES AND MY SKETCHES OF MYSELF, I WAS ABLE TO 'IMAGINE' MY HORSE CHARACTER WITH SOME ACCURACY WITHIN A COUPLE OF SKETCHES. IT'S AS WELL TO BE AWARE THAT ON ANOTHER DAY, AND PERHAPS WITH A LESS FAMILIAR ANIMAL, THE PROCESS MAY HAVE TAKEN A LOT LONGER.

HUMANIZING A CHARACTER

THE PROCESS OF ALLOWING A CHARACTER TO FORM IS PERSONAL. IT WILL BE DIFFERENT FOR EVERYONE AND WILL PROBABLY CHANGE EVERY TIME YOU ATTEMPT IT. THERE ARE NO RULES, ONLY GUIDELINES. SO IT'S A GOOD IDEA TO SEE THE TASK FROM ANOTHER ANGLE OR SOMEONE ELSE'S PERSPECTIVE. TO THIS END, I'D LIKE TO SHOW YOU AN EXAMPLE FROM A GREAT FRIEND AND FELLOW ARTIST, SAMIRA HARRIS, AND GIVE YOU A FEW INSIGHTS INTO HOW SHE CREATED HER CHARACTER 'FREDDIE FOX'.

SAMIRA'S FOX

"The idea of Freddie Fox came from watching a fox sunbathe on my shed. I spent time sitting, observing and wondering about this character's journey. I noticed things that would make me smile and create a feeling of empathy, like when he stretched or scratched, and I started to consider the links between the human and animal expression and where the balancing point in creating an empathetic animal character is."

THE FIRST STAGE OF DRAWING BEGAN WITH VERY ROUGH SCRIBBLES TO JUST PUT DOWN STORY IDEAS.

I THEN BEGAN TO INTUITIVELY SCRIBBLE FOX FACES, THE IDEA BEING TO ENGAGE WITH THE FEELING I HAD GATHERED FROM MY GARDEN FOX AND LOOK FOR CHARACTERISTICS I WOULD LIKE TO INCLUDE IN HIS EXPRESSION. THIS WAS SUCCESSFUL IN THAT THE PICTURES MADE ME SMILE BUT MANY LOOKED MORE LIKE A DOG! I REALIZED I NEEDED TO STUDY THE FOX FROM DIFFERENT ANGLES TO CREATE A 3D CHARACTER.

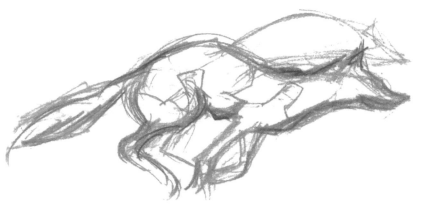

Characters should come from the story you wish to tell, then become inhabited by yourself as an actor

SO I GATHERED A LOT OF REFERENCE. I SOUGHT OUT PHOTOS, BOOKS AND USED SLOW-MOTION VIDEO SEQUENCES TO CREATE A SERIES OF SKETCHES. FROM THESE INITIAL DRAWINGS I TRIED TO ALLOW THE QUALITY OF THE ANIMAL TO SPEAK. I ASKED MYSELF, 'WHAT IS IT THAT REALLY DESCRIBES THE ESSENCE OF A FOX? IS IT THE POINTY EARS, THE SHARP FACE, THE FLUFFY TAIL, OR THE UNIQUE COLOURING?' I REALIZED THAT IF I COULD GET THE CENTRAL FOX QUALITIES RIGHT I HAD THE FREEDOM TO DEVELOP INDIVIDUAL MARKINGS, FACE SHAPES AND OTHER DETAILS.

AFTER THIS, I STARTED THE HUMANIZATION PROCESS. I HAD DRAWINGS OF FOXES, NOW I NEEDED TO CHARACTERIZE THEM. CHARACTERS SHOULD COME FROM THE STORY YOU WISH TO TELL, THEN BECOME INHABITED BY YOURSELF AS AN ACTOR. WHICH EMOTION DO YOU WISH TO PORTRAY? FEEL THAT EMOTION AND TAKE ON THE CHARACTER.

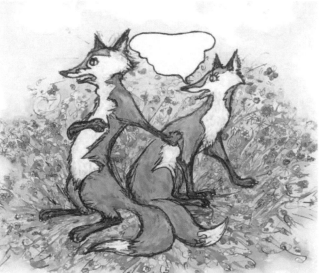

COMPOSING THE PICTURE

IF YOU'VE FOLLOWED THIS BOOK SO FAR YOU HAVE A CERTAIN ABILITY TO DRAW, OR TO REALLY 'SEE'. YOU ARE THUS DEVELOPING A MORE INTIMATE RELATIONSHIP WITH THE WORLD AROUND YOU AND THE THINGS IN IT WHICH INTEREST YOU. YOU WILL BE GRADUALLY STOCKING THE VAST RESERVOIR OF YOUR MIND WITH IMAGES AND IDEAS. YOU MAY ALSO HAVE BEGUN TO SKETCH AND CONSTRUCT SOME CHARACTERS. WHAT NEXT?

The natural next step is to create an environment; somewhere for your imagination and your characters to live and play in. It follows that you are going to want to consider the subject of composition – or putting a picture together. This section of the book will feature some of my paintings as a guide to how I have resolved compositional problems similar to those which you will face and how I have used compositional elements to set the scene or help to tell the story. Of course it is by no means exhaustive; they are but one person's solutions, some more successful than others. The best way to learn about composition is to look at the work of others, discover how they have coped and then be careful to find your own answers.

GUIDELINES FOR HARMONY

Composition can be seen as the bringing together of different elements into one unified whole. The most successful arrangement of those elements would be utterly destroyed if any one of them was moved or removed. You can find examples of this everywhere: in music, in writing, in poetry, in film, in dance, in painting. Remove one word from a successful poem and you can completely alter the meaning of both that word and the poem itself.

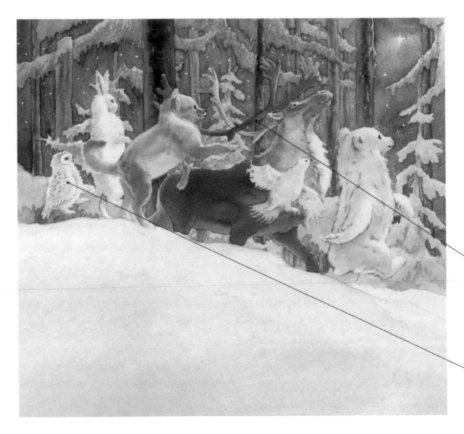

WINTER ANIMALS
This is one of my favourite compositions. First of all, I like the large white foreground of snow contrasting and balancing the figures and the trees. This relief of space allows the viewer to more easily contemplate the detail and gently guides the eye towards it. The procession of vertical trees adds weight to this optimistic movement. The repetition of those forms also confirms a sense of harmony and structure for the group of animals to 'flow' against. I like the shapes of the figures and that there is an easy rhythm in their movement. The negative space between them delineates their forms as individuals so that we can identify each clearly, but also creates a sense of cohesion or friendship as a group. The white bear at the front dominates but in a subtle way; we might surmise that he only thinks he's the leader.

THE COMPLEMENTARY BALANCE OF BLUES AND BROWNS WORKS WELL AND STRENGTHENS THE FEELING OF HARMONY

NOTE THE INVISIBLE CURVE STARTING BEHIND THE OWL ON THE LEFT, CONNECTING THE ANIMALS AND LEADING YOUR EYE EVENTUALLY TO THE STAR — THE OBJECT OF THEIR ATTENTION

Composition is a demanding and precise art but it is also instinctive and individual

There are certain rules of composition that may be taken as guidelines. Always be aware though that, because the solutions are so unique to the individual, there may be occasions where changing the rules will be equally valid – providing you have good reason. The natural world is your starting point in a consideration of that which harmonizes, against that which is out of balance. The Walk in Nature Exercise on page 93 is important in that the more you observe nature, the more you are likely to reflect its endlessly varied attempts to unify. This subject is as infinite as nature itself; the following are just a few guidelines.

DOMINANCE

One rule that you may begin to notice is that of dominance. In any scene there will always be one element that overshadows the others or becomes the leading light. Nature likes to find its favourites. In a group of similar objects or colours, one may be brighter, larger or sharper than the rest. Naturally occuring dominance is subtle, however, and there are all kinds of ways to make one element stand out. Remember the golden rule from Part 2, that under-doing is always more effective than over-doing? Nature is careful not to reveal its secrets all at once, so that which you leave out is therefore of far more importance than that which you include. It can be a real challenge and wonderful discipline to ignore your favourite idea if it doesn't benefit the whole.

These pencil drawings of reindeer show perfectly the contrasts of straight and curved, sharp and smooth, and how simple, quickly-drawn pencil lines can really express form.

REPETITION

Nature repeats and emphasizes. Once again though, the harmony of that repetition depends on subtle variation. The song of a thrush is a series of repeated but ever-changing phrases and tends to evoke an atmosphere of peace and calm. Your compositions may reflect this feeling with a gentle repetition of forms like a sympathetic echo. Listen to a greenfinch and you will quickly notice that it is much less varied and consequently can sound irritating and boring in comparison. For the completely opposite effect, the use of wildly disparate elements would suggest noise, confusion and separation. Hearing the cacophany of sounds from different birds during an attack from a bird of prey will give you a dramatic example of nature's version.

CONTRAST

Nature is also replete with contrast: black and white, detail and space, light and shade, straight and curved, sharp and smooth. The contrast of this book is a balance between free spontaneous drawing and controlled precision. Play with these opposites in your pictures and you mirror nature or reality. Contrast reminds us that life evolves in a constant rhythm of change, subject to laws that are beyond our intellectual comprehension. Interpret that change with your own original voice and you connect with a universal truth.

USING REPETITION

HIPPOGRIFF SUNSET

EVERYONE SEEMS TO SEE THE ACTION IN THIS PAINTING DIFFERENTLY, WHICH WOULD SUGGEST THAT SOMETHING IS OUT OF BALANCE. WITHIN A COMPOSITION I AM OFTEN HAPPY TO PLAY WITH DISCORDANT ELEMENTS, TO KEEP THE AUDIENCE GUESSING. THE GUESSING IN THIS CASE, HOWEVER, WAS UNINTENDED — SO IT'S A USEFUL IMAGE TO EXAMINE.

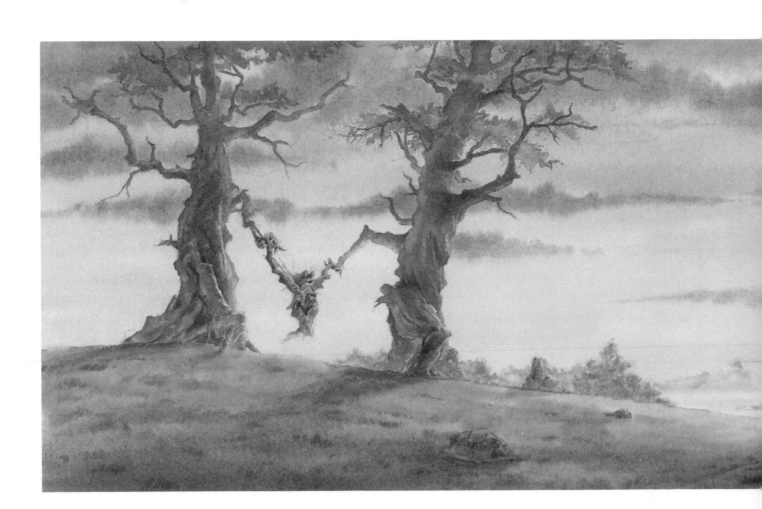

The story behind this painting is that the Hippogriff is watching a peaceful sunset and is intrigued to see two parent trees and their baby interrupting his reverie. Some viewers have read exactly that, others have seen something more sinister in the tree characters.

The sense of peace is partly conveyed by the format of the painting which is long and narrow, and partly by horizontal bands of clouds receding into the distance. Gentle repetition of forms also gives a feeling of harmony. I like the mirroring of the mountains in the shape of the central bush next to the trees and in the foreground rocks; all of these are similar but at the same time not exactly the same shape or colour. The puzzling entrance of the two trees and their baby was intended to create a small ripple on this sea of tranquility. My intention was that the trees should be seen 'swinging' their young one between them – a fairly innocent act. I'm sure the sinister connotation comes from the irregular or jagged shapes of the trees and the disturbance that brings to those regular forms, plus the fact that the baby doesn't look tree-like. Giving it some more branches might have helped, and I would have been better off using smoother-trunked trees. Nevertheless, the dichotomy is interesting.

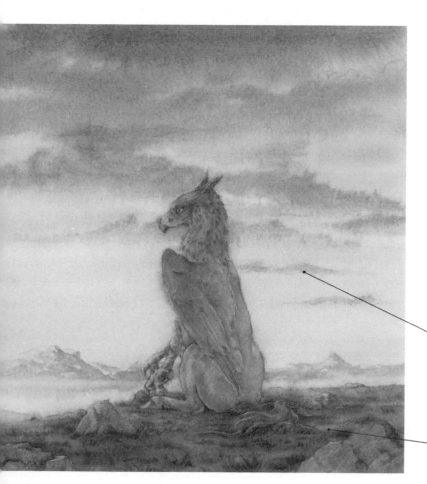

The sense of peace is partly conveyed by the format of the painting which is long and narrow and partly by horizontal bands of clouds receding into the distance

THE REPETITION OF THE RECEDING CLOUD SHAPES, DISTANT MOUNTAINS AND JAGGED FOREGROUND ROCKS CREATES HARMONY ACROSS THE IMAGE

REPEATED COLOURS USED IN THE FOREGROUND AND SKY ALSO HELP TO GIVE THE IMAGE A PEACEFUL FEEL

USING COMPOSITION

YOUR CHOICE OF COMPOSITIONAL ELEMENTS ALL HELP TO CONVEY A FEEL FOR THE STORY AND PROVIDE A SETTING FOR YOUR CHARACTERS. HOW YOU EXPLOIT THESE ELEMENTS AND MAKE THEM WORK TOGETHER WILL ADD GREATLY TO THE SUCCESS OF YOUR IMAGE. MY PICTURE 'AH,' HE SAID, 'I SEE YOU BEGIN TO UNDERSTAND', BRINGS THESE ELEMENTS TOGETHER.

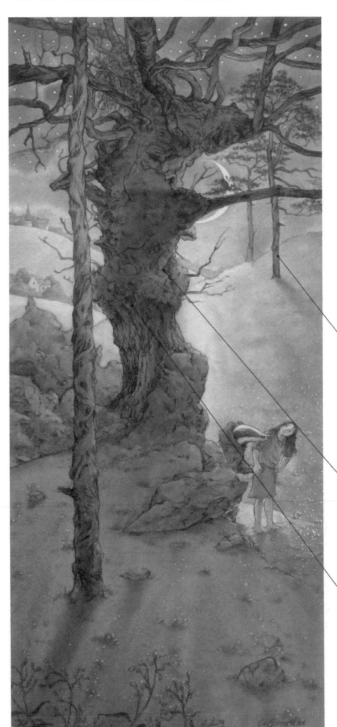

Sit in front of a tree long enough and you may see faces or other elements that seem familiar. This can be seen as just the beginning of the soul remembering its deeper connection with nature. Since the natural world guards its secrets closely I wanted a sense of mystery for this painting or something beyond the obvious.

In terms of content and characters, the badger and the girl are dwarfed by the tree and the landscape. Magic is in the air, the moon and stars cast a soft glow over the proceedings which adds weight to the mood. We have a hint from the buildings in the distance that the two characters have had something of a walk – effort has been made. The tree itself has a 'face'. We can see part of an eye and nose and arm-like branches extending from the 'shoulders'. It appears to be responding to the girl. You may see several characters 'hidden' in the bark of the tree and, within the

COMPOSITIONALLY, I LIKE THE PROCESSION OF THREE STRAIGHT TREES FROM FOREGROUND TO DISTANCE AND THE REPEATED SHAPES OF THE THREE ROCKS IN THE FOREGROUND. BOTH OF THESE ELEMENTS SUGGEST A NATURAL HARMONY

THE TREE INCLUDES MANY FACES, BUT I WANTED ONE TO BE SLIGHTLY MORE OBVIOUS. IF YOU FOLLOW THE GAZE OF THE GIRL YOUR EYES MAY REST WITHIN THE TREE ON THE FACE OF THE FAIRY RETURNING HER ATTENTION

THERE IS A SERIES OF INVISIBLE CURVED LINES LEADING YOU TO THE SAME POINT

shapes of the mossy rocks at its base, lies a sleeping dragon. The badger-guide needed an air of mystery so we only see part of him and ask the question 'Why is he wearing a fur coat?'. The girl's pose suggests her intrigued enquiry though I'm still not happy about the drawing of her – she looks a little awkward.

I have used a tall, thin format to emphasize the scale of the tree and the relative smallness of the girl and badger next to it. The moon illuminates them and your eye is then drawn from the girl's gaze to the face of the tree.

DEVELOPING IDEAS
As with any composition, I drew upon sketches to work out my ideas – how the characters would interact, the position of the main compositional elements such as the horizon and the trees – arriving at a tall, thin format that focuses attention on the main tree and the small scale of the characters beside it.

THUMBNAIL SKETCHES

CREATING A SERIES OF THUMBNAIL-SIZED COMPOSITIONAL EXPERIMENTS IS A USEFUL AND SIMPLE WAY TO PRACTISE YOUR IDEAS AND HELP YOU TO PLAN YOUR IMAGE BEFORE WORKING THE IDEA UP INTO A FINISHED PICTURE. WORKING ON A SMALL SCALE IS MANAGEABLE AND FAST. YOU CAN JOT DOWN VARIATIONS IN A FEW SECONDS AND TRY ANOTHER WITHOUT HAVING COMMITTED TOO MUCH EFFORT.

THERE ARE NO SET RULES

Compositional rules are useful guides but they are not the only solution. There are countless ways to compose even the simplest of elements, so many in fact that it's easy to be overwhelmed, like looking at the stars. At this stage, give yourself the chance to play with the elements of your choice within the frame or even breaking out of it. Developing a knowledge of what does and doesn't work, based on your own observations and looking at your favourite artists will help your confidence in finding your own unique way.

Let's suppose you are creating a composition for two characters, a man and a bear. How will these two react together? How will you set the scene? What story do you want to tell? Here are just a handful of suggestions showing how you can explore ideas through different thumbnail compositions.

For example, will we see your characters in close up? If so, why? Do you want to show the intimacy of their friendship or, maybe, the confrontation of an argument?

Will you picture them close together or will one be distant, suggesting separation... or alternatively, love?

Or will you have a figure cut-off, or leaving the frame (or entering it) giving a sense of a story happening beyond the confines of your image; an idea that time is passing?

Will you picture your protagonists small in the distance, allowing their surroundings to bring meaning to the composition?

Will it be important to you to keep the main detail confined to a small area, such as the upper or lower third?

Will other elements within your composition lend sympathy to your characters?

Or will those other elements dominate, or strike a discordant note?

What about the viewpoint of your audience? Have you considered taking a perspective from above the action – perhaps placing objects between the characters and the viewer, thereby suggesting some secret liaison?

Or will you try a close-up from a low angle which could alter your atmosphere completely?

There are countless ways to compose even the simplest of elements

BREAKING THE RULES

HARRY POTTER AND THE PRISONER OF AZKABAN

Many of you will be familiar with this image from the cover of the book published by Bloomsbury in 1999. In terms of composition it is not at all complicated and I find that simple is often the most effective. The two figures ride on a Hippogriff with the moon as background. The sense wanted was one of high drama underscored with impending danger. There is trepidation but also bravery on the faces of the characters.

The composition supports the mood in several ways and breaks away from traditional compositions – a square format, low viewpoint and the image breaking the edge of the paper all create a sense of drama. The image relies heavily on the movement of the action. The direction of that movement is very obviously diagonally upwards and to the right. So there is an uplifting mood too: scary, but optimistic. Additionally, the direction of the action will hopefully make you the viewer want to go with it and open the book!

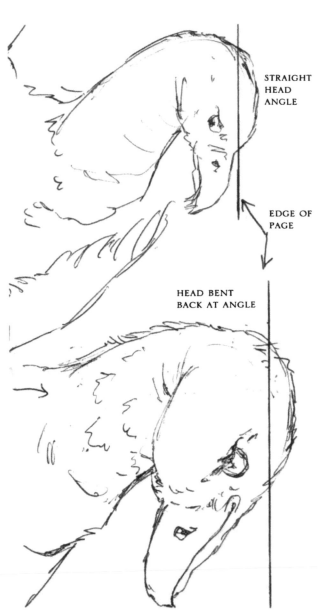

STRAIGHT
HEAD
ANGLE

EDGE OF
PAGE

HEAD BENT
BACK AT ANGLE

My working sketches show how I developed the idea that the hippogriff should dominate the scene, with its head and wings breaking the edge of the paper. A square format is an unusual choice, but it helps to focus on the centralized moon and the two figures breaking the circumference.

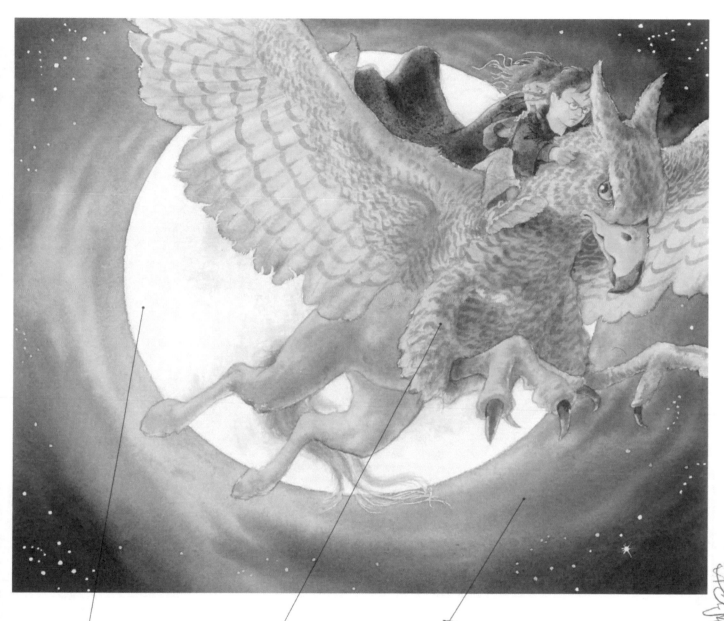

THE BACKGROUND MOON IS VERY
LARGE AND DRAMATIC. THE LINE
OF ITS CIRCUMFERENCE LEADS
YOU THROUGH THE HIPPOGRIFF'S
EYE TO THE MAIN CHARACTER.
THE TWO CHILDREN ARE 'PUSHED'
TOWARDS THE TOP RIGHT INTO A
RELATIVELY SMALL AREA OF THE
IMAGE. PARTIALLY FRAMED BY THE
HIPPOGRIFF'S EAR AND BACK OF ITS
HEAD, HARRY'S FACE IS DOMINANT
SINCE HE IS OF COURSE THE FOCUS
OF THE BOOK

THE VIEWER'S
PERSPECTIVE IS LOW
WHICH INCREASES
THE SENSE OF
DRAMA

THE LARGE AREA OF SPACE
UNDERNEATH THE FIGURES
ALSO CONTRIBUTES TO
THE IDEA OF MOVEMENT.
TRY CLOSING THAT AREA
DOWN AND THE IMAGE
BECOMES FAR MORE STATIC
AND LESS DRAMATIC

USING SPACE

WHEN COMPOSING A PICTURE IT CAN BE VALUABLE TO CONSIDER THE SPACE AROUND AN OBJECT — NORMALLY KNOWN AS NEGATIVE SPACE. BY RECOGNIZING THIS SPACE YOU CAN DEFINE SHAPES, ADD CONTRAST AND EMPHASIS. SPACE IS AN IMPORTANT ELEMENT IN BALANCING YOUR PICTURE TOO — GIVING ROOM FOR YOUR CHARACTERS TO MOVE INTO AND CREATING IMPRESSIONS OF THE STORY BEYOND THE CONFINES OF THE PAGE.

RECOGNIZING NEGATIVE SPACE

Negative space within a drawing is used to explore and achieve harmony of the whole. It also enables the artist, and ultimately the viewer, to see the subject as if for the first time, thereby shedding new light on the familiar.

The attention and emphasis is on the surrounding shapes. For example, a figure can sit within the image space and, by employing successful negative shapes, be part of it rather than appearing separate.

Space is an important element in balancing your picture

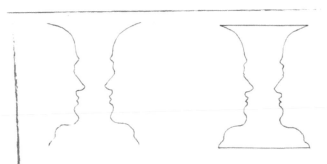

IDENTIFYING NEGATIVE SPACE
A familiar way of visualizing negative space is to look at the two profiles facing each other (above left). Drawing a line across the top and bottom of the facing profiles closes and identifies the negative space between them (above right). Now you can choose to see either the candlestick negative shape or the two original profiles.

This sketch shows the graphic indication of the negative space in the picture. The solid negative space contrasts with the smaller areas of concentrated detail and creates a place into which the creatures might move.

THIS EMPTY SPACE
CREATES A SENSE OF
TENSION BETWEEN THE
TWO CREATURES

THE LINE OF THE
TREE TRUNK USES
THE SPACE FROM THE
LOWER PART OF THE
IMAGE UP TO THE TOP,
TO DRAW YOUR EYE
FROM HARRIET TO
THE DANGER WAITING
ABOVE

WORKING WITH NEGATIVE SPACE
I wanted the composition of If only Harriet had opened her eyes, *to reflect the contrast between the incongruous horse eating chocolate cake and the creeping creatures that belonged in the forest. The expression, movement and poses of the figures all add to the sense of anticipation and drama here.*

COMPOSING WITH SPACE

BOATING BEARS

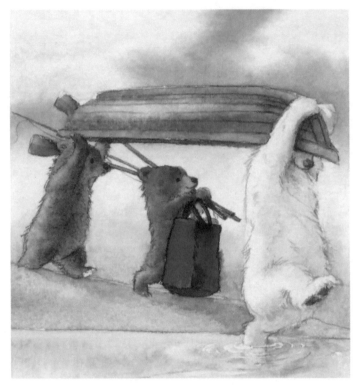

This image was originated as a print and eventually used for the cover of my picture book entitled Three Bears, *where the image was cropped. You can see how the compositional change affects the balance of the space.*

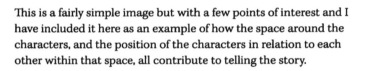

This is a fairly simple image but with a few points of interest and I have included it here as an example of how the space around the characters, and the position of the characters in relation to each other within that space, all contribute to telling the story.

The figures are kept relatively small on the page since the landscape is significant to them. In this scene it was important to suggest the beginning of an adventure so it may be seen as strange that the largest area of space is behind the characters, not where they are heading. This serves several functions: visually, it's a more interesting arrangement; it allows the viewer to contemplate where the bears have come from; it gives a chance to imagine what lies beyond, since little of that is shown. The boat, picnic basket and a slight hint of ripples in the foreground band of water are the only clues. It is likely you are going to want to see what is coming next.

The black bear is the most important of the three. Although he's the youngest and simplest, he tends to arrive at the answers to problems quickest, as if by accident. Thus, he needed to be emphasized. The obvious dilemma is that physically he is the smallest. Positioning and isolating him between the other two bears gives a sense of his status and allows him to dominate but in a subtle way. Further emphasis is given by drawing him carrying the all-important picnic basket.

The white bear is the oldest and largest but is sometimes clumsy or slightly silly. Hiding his head under the boat, but also giving him the leading position answers well for his character. Brown bear is the most hesitant character so it was obvious to have him bringing up the rear.

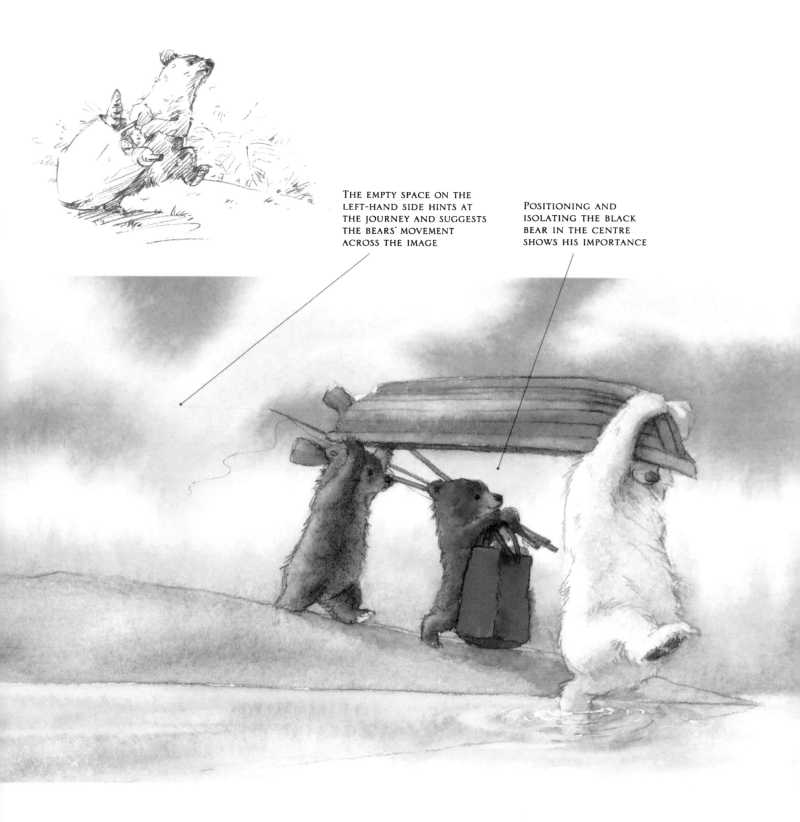

THE EMPTY SPACE ON THE
LEFT-HAND SIDE HINTS AT
THE JOURNEY AND SUGGESTS
THE BEARS' MOVEMENT
ACROSS THE IMAGE

POSITIONING AND
ISOLATING THE BLACK
BEAR IN THE CENTRE
SHOWS HIS IMPORTANCE

DEVELOPING THE STORY

FATHER CHRISTMAS...?

This painting was an experiment with composition. My intention was to play with the size of the figures in the foreground. You can assume that the sledge has made the tracks that lead you into the picture. Taking the size of these tracks from the size of the hare and badger, you would have to conclude that the figure who might be Father Christmas is very small – only a few inches high in fact. From the first, I was trying to acheive a balance between seeing the detail of the foreground figures against creating distance to the background characters, and giving both enough space to tell the story within.

Since there's some uncertainty surrounding the existence of Father Christmas, I wanted some mystery about these characters. Their diminutive size was one idea. Clothing Father Christmas in red and green was another, since these are more traditional colours but less familiar than the modern red and white. Further to the sense of strangeness, I saw him minus his boots which we see carried by a helpful lamp-hatted fairy.

Unfortunately, there is one small but critical detail which mars the desired effect of the characters floating across the space. If you look closely at the first deer he has ended up looking like he's impaled on the twig that in fact disappears behind him. Sadly this is strengthened by the line of shadow on his back from his antlers. Remove the twig or have a look at the original thumbnail sketches where it was absent and the sense of 'floating' is far more effective. A useful lesson in over-doing it!

I THOUGHT IT WOULD BE FUN TO HAVE THE FIGURES 'FLOATING' ACROSS THE SPACE. THUS, THE SHADOWS SUGGEST THAT THEY ARE MOVING JUST ABOVE THE SURFACE, THEREBY NOT LEAVING ANY TRACKS

This series of thumbnail sketches shows how I introduced the idea of the sledge tracks to lead you through the picture, breaking their path with the tiny figures in the foreground.

THE POSITION OF THE DEER GIVES THE UNINTENTIONAL EFFECT THAT HE IS IMPALED ON THE TWIG

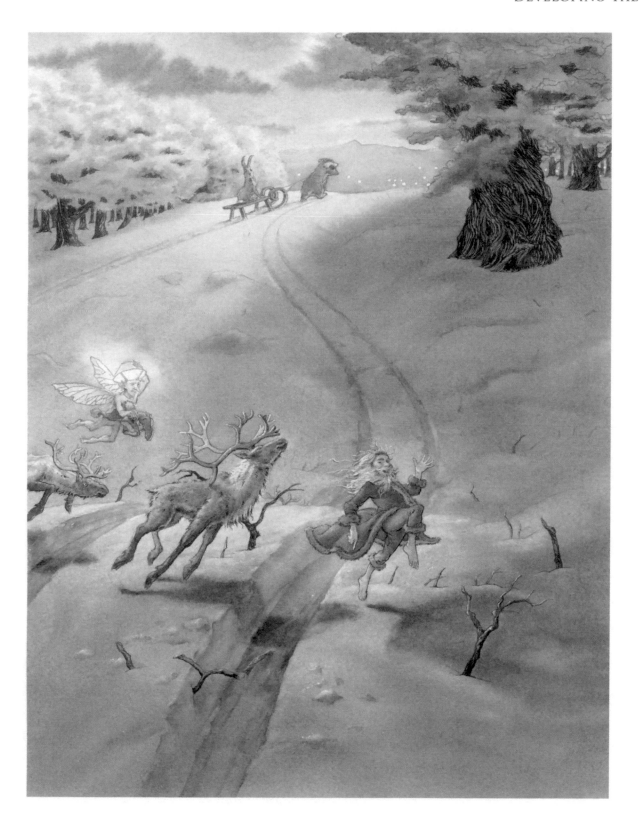

SETTING THE SCENE

IF YOU'VE REACHED THE STAGE WHERE YOU HAVE DEVELOPED A CHARACTER, IT FOLLOWS THAT YOU'LL WANT TO GIVE IT A HOME OR ENVIRONMENT TO LIVE WITHIN. IN PRACTICE THE CHARACTER AND THEIR SPACE PROBABLY WON'T BE CONSIDERED IN ISOLATION. EVEN AS YOU DEVELOP YOUR PROTAGONIST YOU WILL MOST LIKELY BE CONSIDERING ITS ENVIRONMENT.

We are part of our surroundings and they are obviously part of us and reflect our nature. Will your backdrop be inspired by a real place, such as in the case of my bears from Canada? Or will you create a completely new landscape from a fantasy world? Will your character need to interact with others and if so, how will their landscape lend support? Once you've decided on the nature of this space, how will you compose it? What will you include and, more importantly, what will you leave out to tempt your audience's imagination? What time of day or year will it be? How will you light the scene? The questions are endless...Consider the paintings shown here. Both rely heavily on landscape and are similar in colour, but clearly they portray very different moods.

THE TWO CHARACTERS ARE KEPT VERY SMALL. IN FACT IT'S HARD TO EVEN SEE THE OWL UNLESS YOU FOLLOW THE DIRECTION OF THE FOX'S GLANCE

THE LIGHT OF THE MOON SATURATES THE SCENE AND THE RESULTANT SHADOWS FROM THE TREES CONVEY A FEELING OF GENTLE MOVEMENT

THE CALM FEATURELESS BODY OF WATER ADDS TO THE MOOD OF SERENITY, AS DOES THE SENSE OF A SILENT, STILL FROST

THE LANDSCAPE DOMINATES AND SURROUNDS THESE TWO IN COOL WINTER MOONLIGHT. THERE IS A SENSE OF PEACE AND HARMONY AND THE TWO CREATURES ARE VERY MUCH AT HOME WITH THEIR SURROUNDINGS

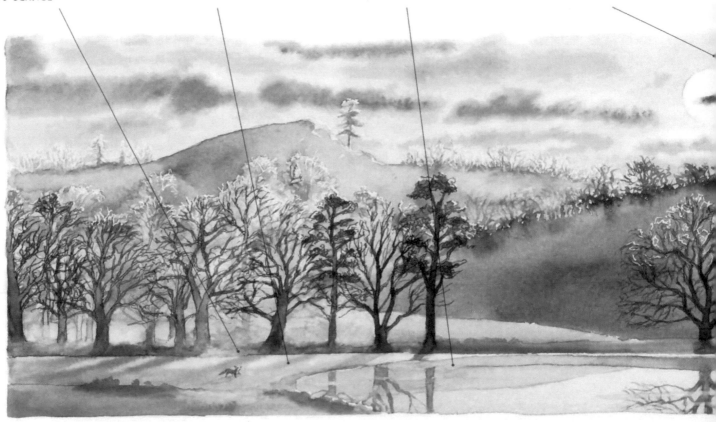

THE WHOLE OF THE TOP HALF OF
THE IMAGE IS GIVEN OVER TO A VERY
THREATENING, ALMOST APOCALYPTIC
SKY, ADDING TO AND DOMINATING THE
FEELING OF WASTE AND DESPERATION

THE INSPIRATION FOR HOW THIS
DEVASTATED LANDSCAPE LOOKS WAS A
MOVIE THAT WAS SET IN THE TRENCHES
OF THE FIRST WORLD WAR. I WANTED
THE SCENE TO LOOK LIKE A PLACE
WHERE MUCH SUFFERING HAS OCCURRED
AND ALL HOPE WAS GONE — A VERSION
OF WHAT WE APPEAR TO BE DOING TO
OUR PLANET

INTO THIS SCENE, BUT AT ODDS TO
IT, ENTERS AN EARTH CHARACTER
PRESENTING A NEW TREE — A GREEN
SYMBOL OF HOPE

SOMETHING WAS NEEDED TO BALANCE
THE LARGE EXPANSE AND HUMANISE THE
PIECE, HENCE THE FOREGROUND DETAIL
WHICH INCLUDES A BROKEN BICYCLE
WHEEL AND A DEAD DEER — WE HAVE TO
GUESS WHAT HAPPENED TO THESE TWO;
SO SOMETHING IS LEFT OUT

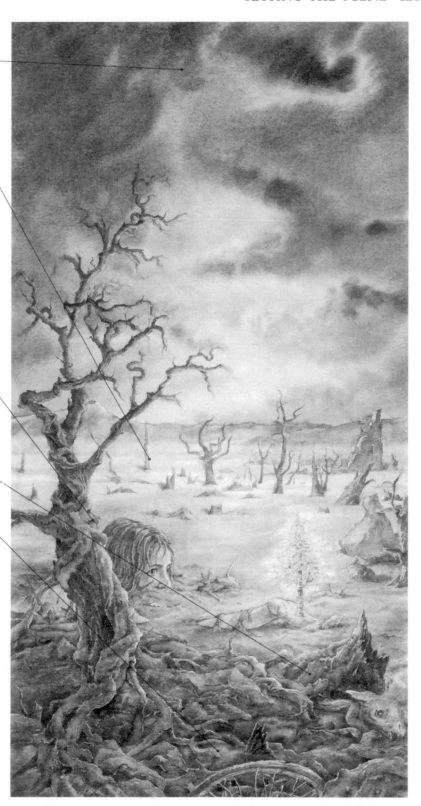

AWAKENING

THE OPPOSITE IMAGE WAS CREATED FOR THIS BOOK AND ORIGINATED FROM A DRAWING THAT I MADE FOR A FRIEND IN THEIR SKETCHBOOK. YOU MAY HAVE SPOTTED THE DEVELOPMENT OF THIS CHARACTER ON SOME OF THE PREVIOUS PAGES, GROWING FROM A BOY INTO THIS RATHER CURIOUS WOLF/MAN/TREE CREATURE.

As you know, the message of this book has been to focus attention away from the result and on to the journey. Thus, I thought, it would be interesting to try creating a drawing with no fixed idea of its outcome. The image was therefore drawn over a period of several months, on and off, mostly with a ballpen, occasionally with ink, drawing pen and brush, but never with any pencilled preparation lines - which would normally be the case for me. This had the happy effect of really concentrating my attention, since nothing could be erased or corrected. Letting the picture 'compose' itself was also an intriguing discipline. It was great to include elements that I came across day to day, that I didn't expect to include. The tree, for example, became the top half of a wonderfully barked specimen that I found in Prague and the lower half a very large beech found by accident on the banks of a river in Sussex and remarkable for its extraordinary exposed roots. Judge for yourself how successful or not you think the image is.

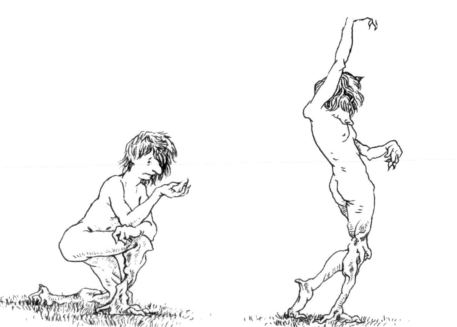

AWAKENING
This finished drawing was made directly with pen. Unusually, the finished drawing went onto the page fully formed. This led me to explore the development stages of the central character and its origins from a boy.

'Drawing is the discipline by which I constantly rediscover the world. I have learned that what I have not drawn I have never really seen, and that when I start drawing an ordinary thing I realize how extraordinary it is, sheer miracle.'

FREDERICK FRANCK — THE ZEN OF SEEING

CONCLUSION

So, where has the journey of this book led you to? At last it's time to consider the result! My hope, first and foremost, is that you will have increased your confidence with drawing and have a genuine sense of the true creativity that lies within you. I also hope that you will have gained a heightened appreciation of the subtleties of a drawn line and how small moments of success are just as important as a complete masterpiece. I trust that you will now know some of the value of developing good, solid practice out of which to allow your achievements, however small or large, to grow. I hope you will be encouraged to continue with and value your efforts and that you found inspiration and support within these pages. Lastly, I hope you've realised how drawing can enable you to see, as if for the first time, the remarkable beauty and diversity that surrounds us at all times. Thanks for reading and good luck with the on-going journey...

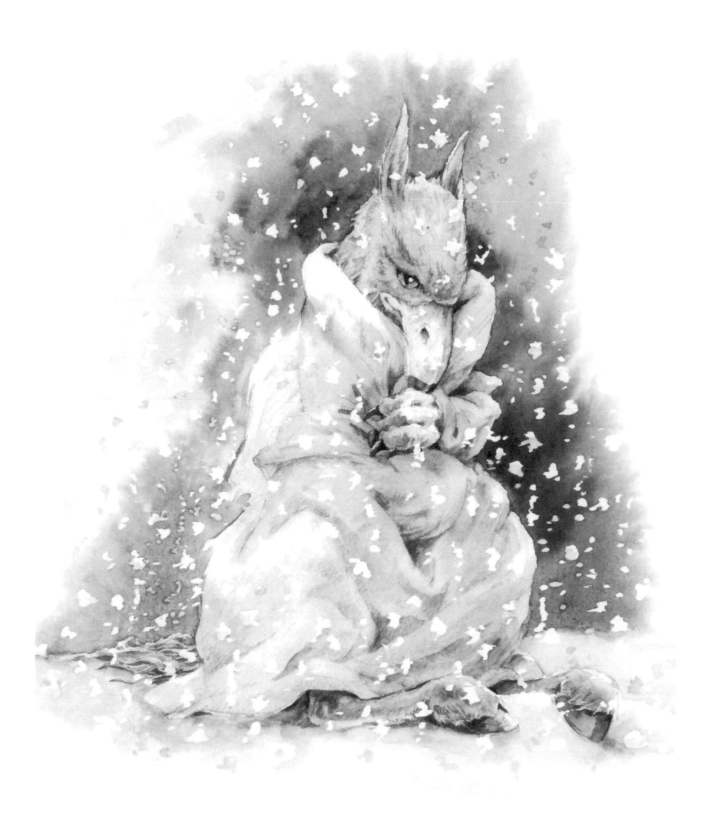

ABOUT THE AUTHOR

Cliff Wright has over 17 years experience as a children's illustrator. His books are published in the UK and abroad, but in recent years he is best known for producing two of the Harry Potter book covers – *Harry Potter and the Chamber of Secrets* and *Harry Potter and the Prisoner of Azkaban* (both published by Bloomsbury).

Cliff has produced many successful children's books, inspired by his love of animals and the countryside. He also regularly does high profile work for advertising and design clients. He enjoys introducing everyone, including school children and business clients, to new ways of seeing. Cliff runs regular workshops throughout the UK, more details of which can be found on his website.

www.cliffwright.co.uk

ACKNOWLEDGMENTS

Love and thanks to Kathryn, for typing when you would have rather been outside, checking the grammar, your eye for detail, your love and most of all for being there.

Special thanks to Samira for those magical drawing days, your astounding energy, relentless enthusiasm and selfless support – you are a great friend.

I am also especially grateful to these friends: to Denica for your stillness and allowing me to use some of your wonderful drawings and ideas; to Gary, for your interest and thoughts; to Phyl for even more typing; to Nathalie for our beautiful connection and your way with words; to Toni for your walks and original thinking; to Sophie, for your friendship and feathers; to Chloe for the use of your amazing sketchbooks; and to Tim, John, Fi and Helen and all who contributed such fantastic apples!

A big last but not least thanks to Freya (for asking me to do it in the first place); to Katie, for being a delight to work with; to Em, for your patience with all my suggestions, to Martin for your last-minute efforts, and to all at David and Charles for producing these ideas!

INDEX

Ablett, Jackie 19
Aristotle 14
Arp, Hans 12
Art in Action 9
attention 24–5, 52

bears 8–9, 96–9, 96–9, 104, 116, 116–17, 125
'big picture' 22–3
birds 23, 36, 59
Brewer, Nathalie 30
Brown, Tom 22
brush strokes 78, 79
brushes 55

challenges 33, 34–5
characterization 96–103, 96–103
charcoal 60
Christmas scenes 8–9, 118, 118–19
close ups 111, 112
composition 104–22, 104, 106–23
confidence 19–20, 29
context 98
contrast 105
creativity 32, 38, 88–90, 99
cross-hatching 66, 68

deer 8, 16, 104, 125
detail 42, 43
determination 33
discipline 32–3, 52
distance drawing 74
dogs 59, 61, 94
dominance 105, 112–13, 116, 117
doodling 90, 90–1
Doré, Gustave 85, 85
drama 112, 113

Edwards, Ann 19
erasers 55
essence 14, 15, 50, 103
exercises
 A Walk in Nature 93
 Changing Hands 38, 38–9

Changing Light 69
Delicate Touch 78, 79
Drawing from a Distance 74
Drawing Small 76, 77
Exploring a Line 64, 65
Feeling Faces 82, 83
Free Your Imagination 92
Freeform Drawing 62, 63
Looking Deeper 42, 43
Memory 40–1, 41
Movement 45
Negative Space 80, 81, 114, 114–15
Observation 22–3, 26–8, 26, 28–31, 32, 35
Owl Vision 22–3, 23, 41, 93
Precision 67
Rendering The Play of Light 70–1, 71
Seeing 14, 16, 18, 18–21, 21
Seeing Light 68, 69
Sense 24–5
Shading 66

faces 82, 83, 90–1
fairies 22, 34, 82, 118, 119
Father Christmas 118, 118–19
feathers 12, 26–8, 26, 28–31, 38, 38–9, 40, 42, 43, 60
figures 14, 15, 16, 17, 59
'flow' 32
Forbes, Caroline 20
form, essence of 14, 15
foxes 32–3, 102–3, 102–3, 120
free composition 122, 122–3
freeform drawing 62, 62–3

Grahame, Kenneth 48
Greenpeace 9

habits, breaking 35
hands
 light on 70–1, 70–1
 using simultaneously 64
 using your 'other' 38, 38–9
Harris, Samira 41, 63, 70, 75, 102

hatching 66
Hill, Edward 24
horses 100–1, 100–1, 115
Hughes, Margaret 21
humanizing animals 97, 97–103, 99–103, 116–17

imagination
 drawing from 86–103
 freeing your 88–9, 92
ink 55
innovation 34–7
inspiration 33
invisible sketches 37
Jordan, Kathryn 28–9, 43

Klee, Paul 34
Kriyananda, Swami 50

leaves 61, 75
Leonardo da Vinci 44, 66, 84, 85, 85, 92
life drawings 94–7, 94–6, 101
light 66, 68–72, 68–73, 75
lines, exploring 64, 65
looking deeper 42, 43

masters 84–5, 84–5
memory, drawing from 40–1
Michelangelo 84, 84
Miller, Sophie 39
movement 44–8, 44–9, 112, 113
Mucha, Alphonse 85, 85
music 62, 63
mythical animals 10, 24–5, 106–7, 112–13, 115, 122, 122–4

nature 93, 105
negative space 80, 81, 104, 114, 114–15
Nenova, Denica 65, 68

observation 22–3, 26–8, 26, 28–31, 32, 35, 96
 angle of 35
open minds 92–3

optical illusions 114
owl vision 22–3, 23, 41, 93

paper 54, 62
Paperlink 9
Parnwell, Mary 38, 43
patterns 22, 115
pencils 54, 61
 full range 58, 58–9
 gripping 67
 sharpening 56–7, 56–7
pens
 ballpoint 54
 drawing 55
 mapping 55
 marker 60, 61
peripheral vision 22–3
persistence 33
Pissarro, Camille 88
Pole, David 18, 18
Potter, Harry 6–7, 72–3, 112, 112–13, 124
presence 19
progress assessment 18, 28, 47

Rackham, Arthur 85, 85
repetition 105, 106–7, 106–7
Ruskin, John 40, 52, 78

Saraswati, Shri Shantananda 32
scale 37, 76, 77
scene setting 120, 120–1
seeing 12–51
senses 22, 24–5, 27, 93
shading/shadows 61, 66, 68–72, 68–71,
 75, 76, 77
shape 16, 17, 29
sketchbooks 88–9, 88–9
small drawings 76, 77
snow scenes 8–9, 104, 118, 118–19
soft media 55
solidity 18, 18
space 80, 81, 104, 114, 114–15
story telling 118, 118–19
subconscious mind 90
subject choice 33
sunsets 69, 106–7

Tchaikovsky, Pyotr Ilyich 33
thoughts, calming 24–5
Three Bears 98, 98–9, 116, 116–17
three-dimensionality 20–1, 29, 31, 39, 43,
 75, 79
thumbnail sketches 110, 110–11
time issues 33, 37
tools 54–62, 54–63

touch
 controlling 66–7
 delicate 78, 79
 refining 74, 74–5, 80, 81
trees 13, 41, 41, 59, 80, 81, 86–7, 106–8,
 108–9, 114, 115, 120–3, 122

viewpoints 35, 111, 113
visualization 92

Wind in The Willows 48, 48–9
Wright, Cliff 30–1, 43, 63